NY _{THROUGH THE} LENS

VIVIENNE GUCWA

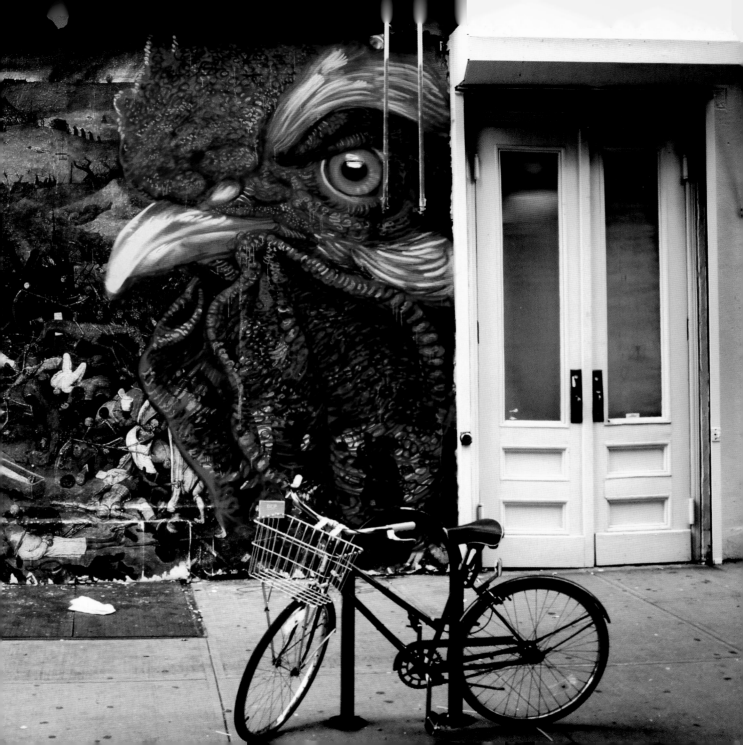

NY THROUGH THE LENS

VIVIENNE GUCWA

PRINT

CINCINNATI, OHIO
WWW.PRINTMAG.COM

NY THROUGH THE LENS

Published by PRINT Books, an imprint of F+W,
a Content and Ecommerce Company. 10151 Carver
Road, Suite 200, Blue Ash, Ohio 45242. (800) 29-0963.
First edition. For more excellent books and resources
visit www.fwmedia.com.

18 17 16 15 14 5 4 3 2 1

ISBN: 978-1-4403-3958-5

This book was conceived, designed, and produced by
The Ilex Press, 210 High Street, Lewes, BN7 2NS, UK

For ILEX:
Publisher: Alastair Campbell
Executive Publisher: Roly Allen
Commissioning Editor: Adam Juniper
Editorial Director: Nick Jones
Senior Project Editor: Natalia Price-Cabrera
Senior Specialist Editor: Frank Gallaugher
Assistant Editor: Rachel Silverlight
Art Director: Julie Weir
Design: Made Noise

All images © Vivienne Gucwa

Color Origination by Ivy Press Reprographics

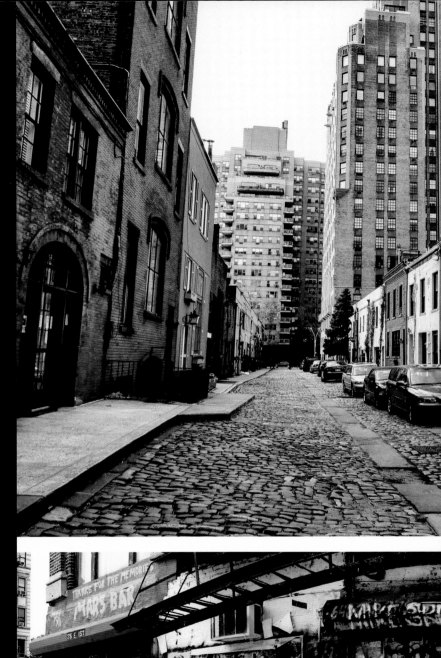

CONTENTS

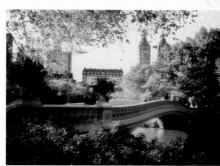

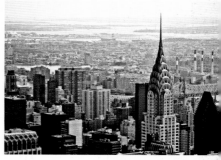

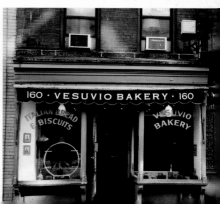

INTRODUCTION

There are certain colors that dominate memory. They are infused with the hues of dreams and mixed on the palette of the mind's eye. But it's the tones of nostalgia that stand out the most: lingering longing for places and moments we have or have not experienced that creates a void in our beings so deep that its echo is felt in every moment.

I am endlessly haunted by a sense of *saudade* and *sehnsucht* as I explore the world with my camera. *Saudade* is a word of Portuguese origin that refers to an intense desire for something other than the present; a dreamy wistfulness for things that are not found in the present environment. *Sehnsucht* is a word of German origin that can refer to a nostalgic longing for a faraway place that may or may not exist in reality but feels like home. Both of these types of longing are so profoundly experienced that ordinary reality usually pales in comparison.

Photography is a powerful artistic medium that allows us to tap into these intense feelings of nostalgic longing. All the sensory influences that we carry with us in our minds that affect how we view and relate to our environment are also shared by others to varying degrees. And we can use those sensory influences to tap into a universal nostalgic longing that will allow us to distill the essence of any place into distinctive visual remnants that universally evoke a slew of powerful emotions.

I started taking photos in a rather stream-of-consciousness manner in 2009. Without much in the way of material things or financial prosperity, walking became my way to deal with stress. It also became a way for me to experience New York City as I never had before. I would choose a direction and walk as far as my feet would take me; I still do this. As the scenery unfolded before me, I began noticing lines, forms, and structures that I'd previously ignored. To embrace my new-found sense of wonder, I took the only camera I could afford at the time, a simple point-and-shoot costing less than $100, on my walking adventures. I just wanted to capture the moments and experiences that made my heart swell.

In 2010, I finally decided to post the photos I had accumulated along the way online. Since I had no formal training in photography or in-depth knowledge of the rules and concepts defining the field, it didn't occur to me that I'd have an audience for my work. Having limited tools enticed me to learn more about light, which in turn has set me on a lifelong journey attempting to capture something as fleeting and vast as the transient quality of New York City and other places around the world.

While photography didn't find me until later in life, my passion for writing occurred much earlier. I discovered my love for writing while taking art history classes many years ago. My love for the subject of art was nearly trumped by my love of writing about art. I would spend countless hours analyzing what it was about a particular work of art that resonated in a universal way. It was in those same art history classes that I also developed a love for painters who found ways to evoke powerful emotions deftly using color and light. Painters like Edouard Léon Cortès and John Atkinson Grimshaw, who could masterfully portray a range of emotions in cityscapes and landscapes with the loosest brushstrokes of paint, inspired pages and pages of writing and musing about their artistic brilliance.

This book is a series of narratives and thoughts about New York City, set to the New York City that exists in my mind. When I have my camera to my eye and I am thinking about the countless stories that are unfolding in front of me, I am at the core a dream catcher and moment collector.

I hope that you enjoy these dreams and moments.

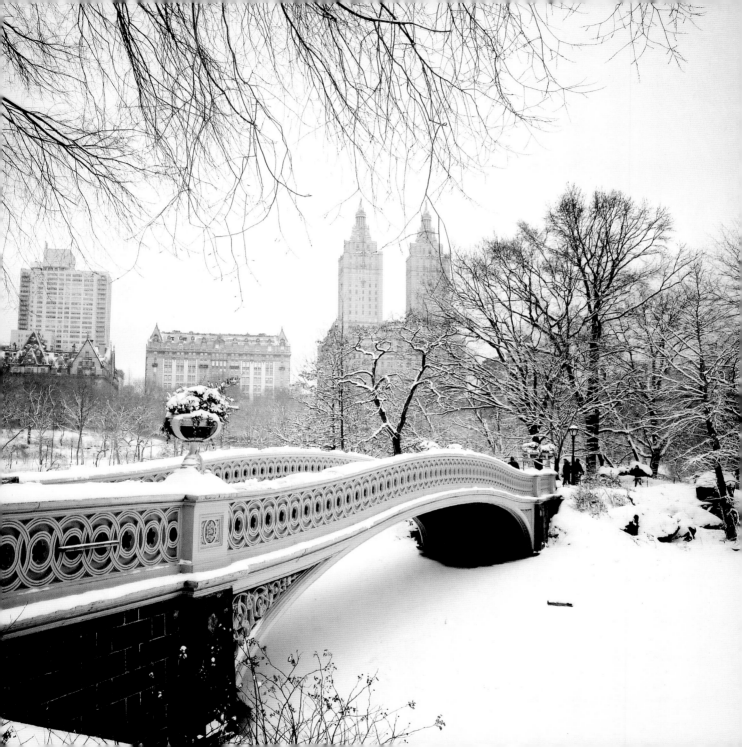

CHAPTER #1 | # STREET NARRATIVES

"There are streets that I return to over and over again.

These streets tug at memories I haven't made yet while yanking memories I treasure from the deep recesses of my mind.

They haunt me in all the best ways.

They represent the New York City in my mind. Everyone seems to have a different version of New York City in their mind. It's the version that they look for when turning a corner and glancing down a street."

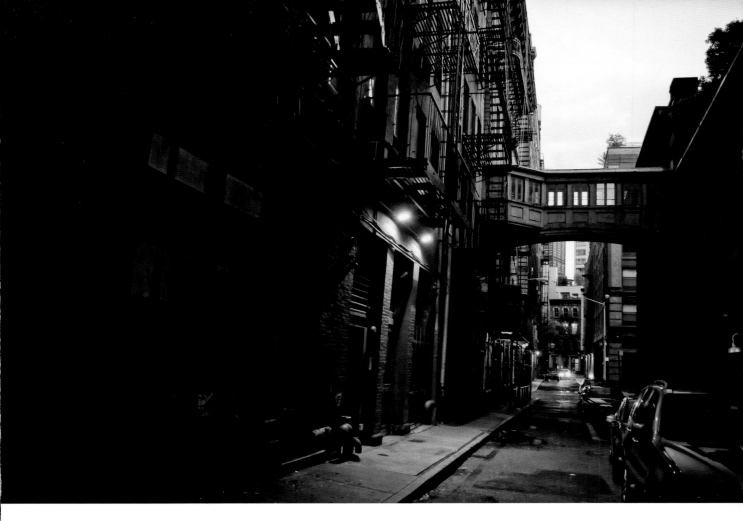

▲ Staple Street, Tribeca, Lower Manhattan
Sony SLT-A55V | ƒ/5 | 1/250 second | ISO 400

My own version of New York City was formed early on. It's a result of falling in love with a combination of streetscapes in classic film noir, futuristic sci-fi city environments in literature and film, and years of traversing New York City on foot.

This is one of those streets that I could have only dreamed existed until I turned a corner one day and stopped dead in my tracks as I looked down the street towards the skybridge that crosses between buildings. It's Staple Street in Tribeca. A tiny alley-like street, it contains one of the most fascinating pedestrian bridges I have ever seen in New York City.

When I began taking photos of New York City, the movement of its inhabitants and its constantly evolving backdrop was a never-ending source of wonder. Minutes would turn into hours as I waited for the perfect character to candidly enter the scene I wanted to capture. Stories unfold on the city's streets just waiting for a press of the shutter button to immortalize them, one frame at a time.

In a city full of people the pauses between moments of frenetic activity are some of the most beautiful moments.

These pauses tell their own stories.

Empty café tables just beyond an open door beckon explorers to sit a while and embrace solitude. Faded signs on deep red brick are the left-over pieces of another time's tales.

And as the late afternoon sun dances along quiet street corners like this one, the evening waits a little longer as it revels in the peaceful slumber of the day.

A Tribeca street corner in Lower Manhattan
Sony SLT-A55V | f/4.5 | 1/200 second | ISO 200

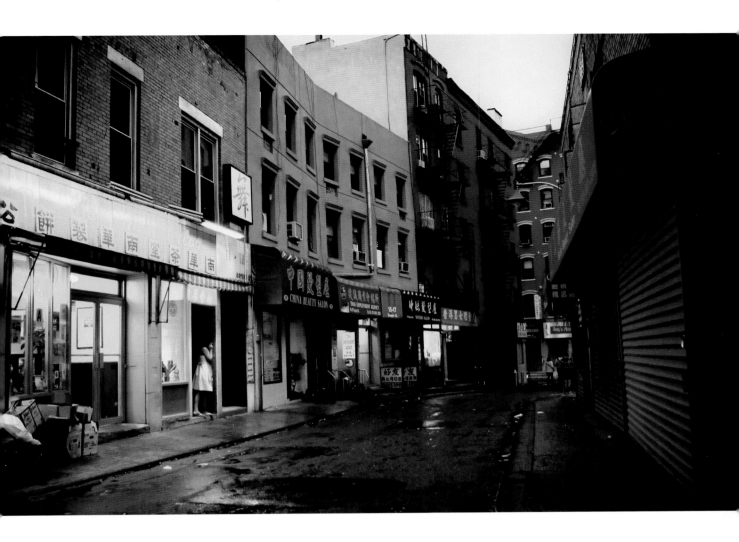

Doyers Street, Chinatown, Lower Manhattan
Sony SLT-A55V | f/4.5 | 1/60 second | ISO 400

ometimes the mundane is transformed into something magical via photography. Chasing light and understanding the nuances of light during different times of day can become something of an obsession. Appreciating how certain sunlight can transform an ordinary scene is something I never take for granted.

Perry Street in the West Village, Lower Manhattan
Sony SLT-A55V | *f*/4.5 | 1/60 second | ISO 200

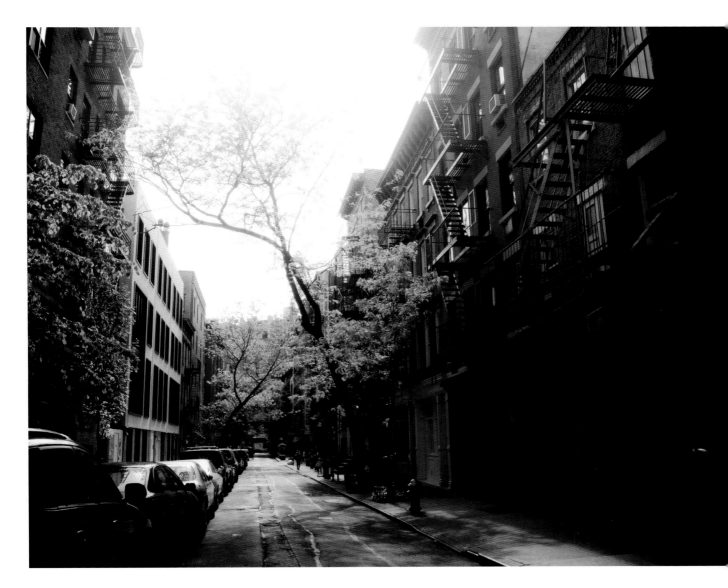

In this scene, for example, fire escapes catch the sun's gleam, as if they are staircases propelling dreams skyward. And as the trees bow in the glow of the sun, they seem to beckon wanderers into the scene to share in the late afternoon light and warmth spilling onto the street below.

A side street directly connected to Bleecker Street in Greenwich Village, Lower Manhattan
Sony SLT-A55V | f/4.5 | 1/80 second | ISO 200

The Lower East Side and the East Village,
Lower Manhattan
Both photos: iPhone 4S

Midtown Manhattan
Sony NEX-6 | ƒ/5 | 1/60 second | ISO 100

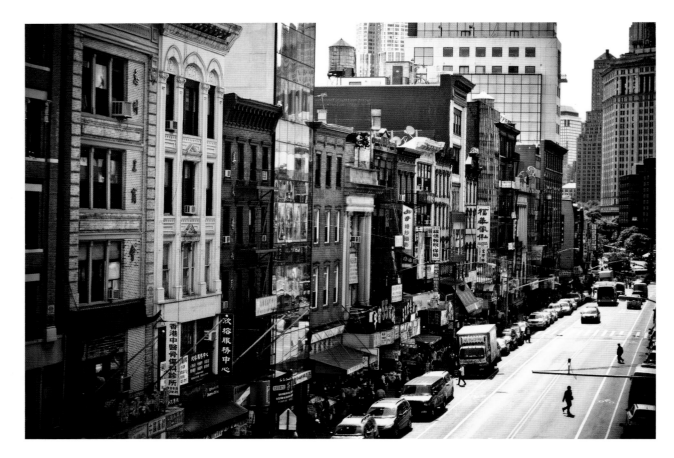

▲ East Broadway, Chinatown, Lower Manhattan
Sony SLT-A77 | f/7 | 1/60 second | ISO 100

I grew up the child of an immigrant to the United States. My mother's family fled Eastern Europe after World War II. Her family was a victim of the war—concentration camp and labor camp survivors who carried with them mental scars so deep that it took years to gain even a small foothold here.

I have always felt disconnected from her experience though. My mother wanted her children to blend in rather than stick out, as she did when she immigrated here. She did her best to give me and my brothers a fairly normal American childhood in Queens. A decade ago, after delving into my own fascination with the history of New York, I started to ask her about her own immigration story. Only then, did I start to understand the gravity of what it means to come to a place like New York City with little more than a massive amount of dreams.

Shortly after moving to the Lower East Side from elsewhere in Manhattan, I came across this street (the one in the photo above). It sits in a neighborhood that borders the Lower East Side and Chinatown, and when I found it, it felt as if I could finally understand what it must have been like for my mother and for all those who came to America with eyes full of hope.

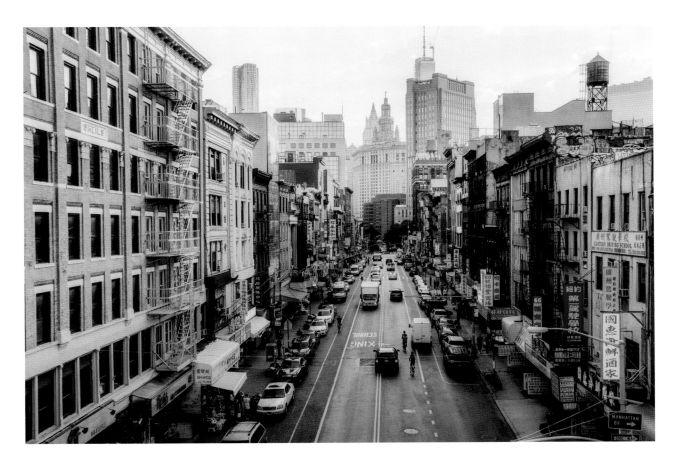

East Broadway, Chinatown, Lower Manhattan
Sony NEX-6 | ƒ/3.5 | 1/125 second | ISO 100

It's not that my mother settled here. Rather it's as if this street has been steeped in a time when the world and New York City was a different place, one that held out vast fortune in its hands. The world has changed quite a bit since my mother first set foot here. It's harder to come here with next to nothing and make a decent life for yourself. The hands are still held out, but they are no longer outstretched for everyone.

When I look at this street today, I see many of the original tenements that were standing one hundred years ago, when waves of immigrants came to New York City. Those who traverse this street today are not so far removed from my mother. It's as if, for the few minutes that I spend gazing down onto this street below, as I often do, I am connected in a deeper way to all the dreamers that called and still call New York City their home.

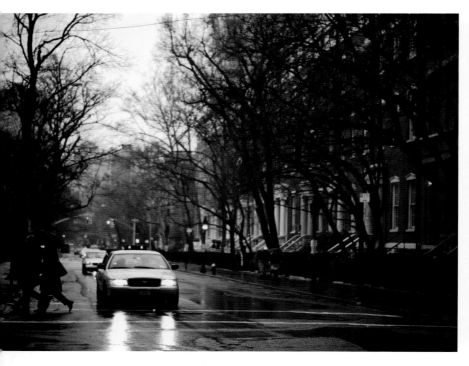

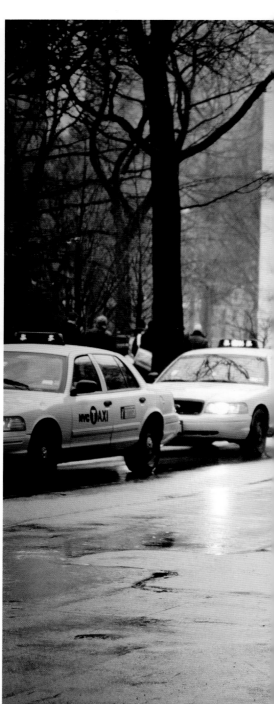

△ Washington Square, Greenwich Village, Lower Manhattan
Sony SLT-A55V | *f*/1.8 | 1/100 second | ISO 200

▷ A street adjacent to Washington Square Park
in Greenwich Village, Lower Manhattan
Sony SLT-A55V | *f*/4.5 | 1/200 second | ISO 200

There is an adrenaline rush that occurs with street photography. In a split second, a scene presents itself as if it were a staging area. Take the image right.

The eyes sweep over and frame the scene. Every element seems to come together at once: trees with their winter-bare branches hang over the street, a line of yellow taxi cabs waits at a nearby traffic light, the sidewalk glistens in the rain, distant figures cross the street in the distance. All at once, the perfect figure enters the scene with a red bag and a red patterned umbrella that pierces through the winter gloom.

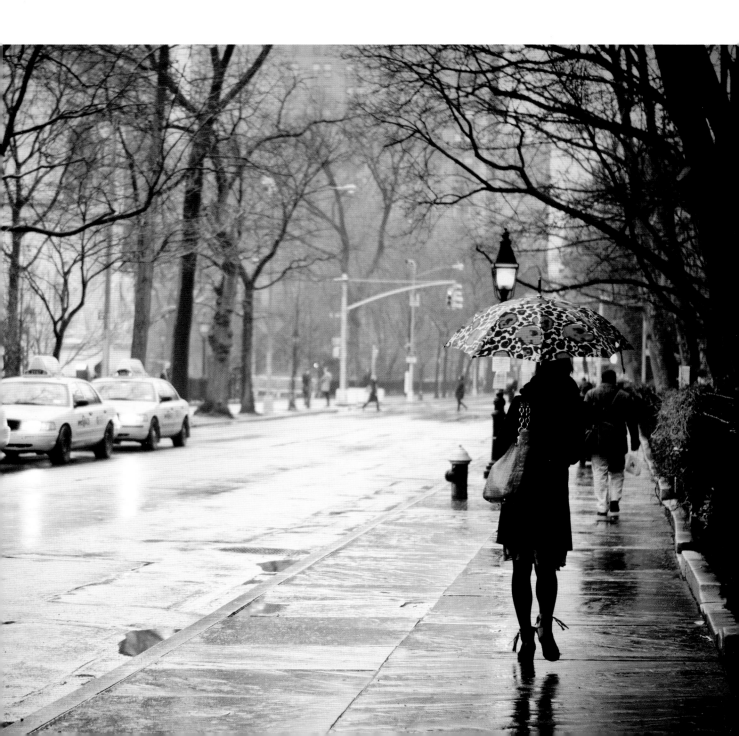

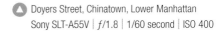 Flatiron District, Midtown Manhattan
iPhone 4S

Doyers Street, Chinatown, Lower Manhattan
Sony SLT-A55V | f/1.8 | 1/60 second | ISO 400

Flatiron District, Midtown Manhattan
iPhone 4S

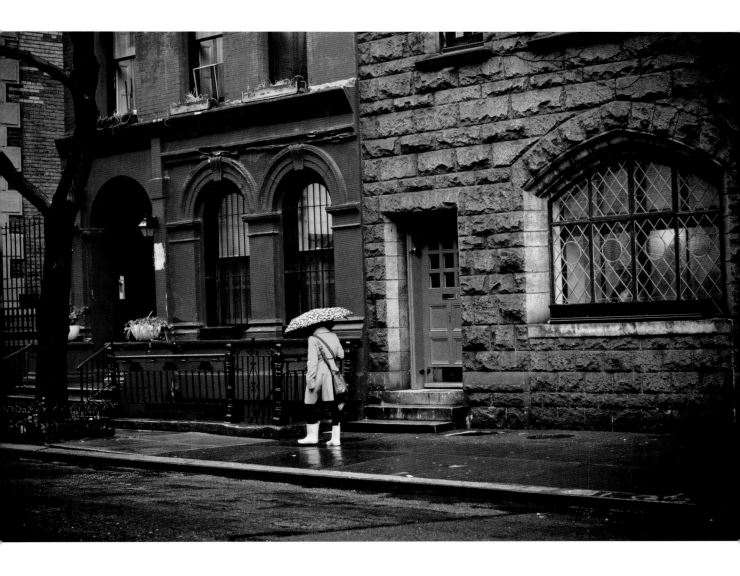

Greenwich Village, Lower Manhattan
Sony SLT-A55V | ƒ/5 | 1/80 second | ISO 800

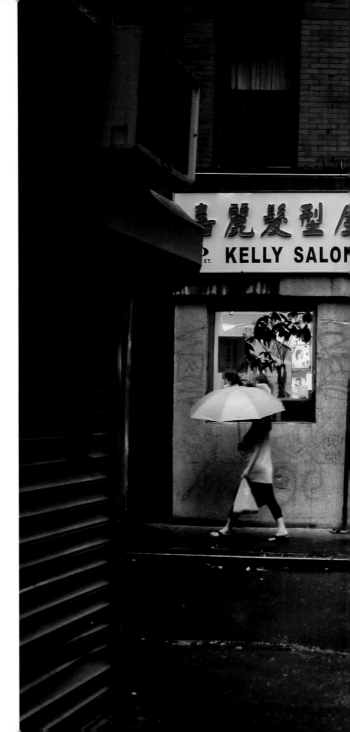

Pell Street, Chinatown, Lower Manhattan
Sony SLT-A55V | *f*/2.2 | 1/80 second | ISO 200

Summer days in New York City can be oppressively humid and this was one of those days. The air was thick and the evening's cooking smells hung over the wet buildings and streets slick with warm rain.

I've taken dozens of photographs of this particular street corner, but what was it that differentiated this photograph from others? Why did this one resonate while the others fell short? The deciding factor was the series of actions that sparked a narrative I wanted to convey, when I set out to document what a moody, rainy summer day felt like in Chinatown.

The woman in the foreground turns the corner carrying a lavender umbrella and a bag of groceries; two people huddle under an umbrella in the distance on the edge of the sidewalk to avoid the open doors of stores; a person leans out of one of the open doors to enjoy a cigarette while watching the rain; a man crosses the street with bags of groceries; and another person leisurely leans in front of a store to seek some semblance of relief from the humidity.

All of these moments occurring together against this brilliantly colorful backdrop resplendent with light and reflections conveyed the story I was trying to tell with my camera about how this part of New York City feels on an achingly hot and humid evening in a rainstorm.

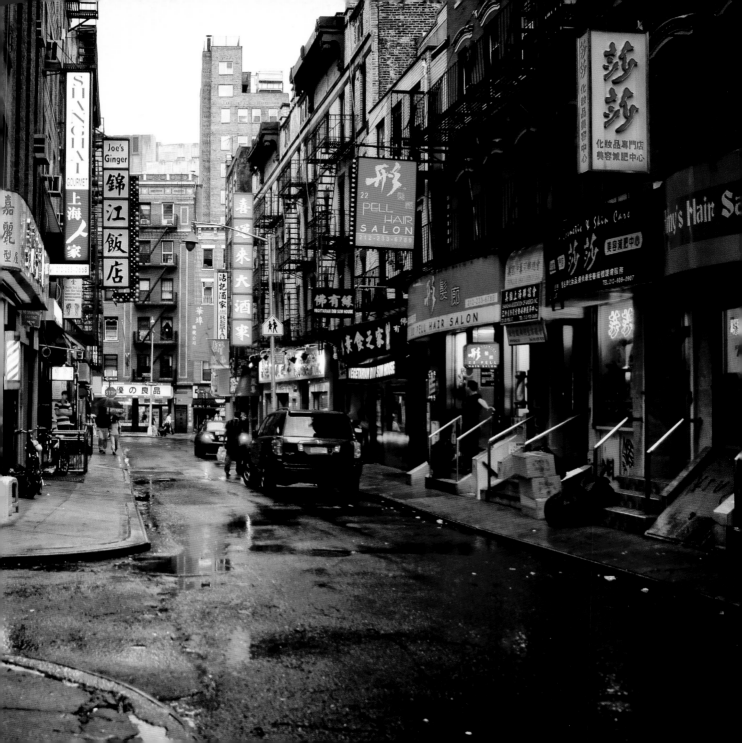

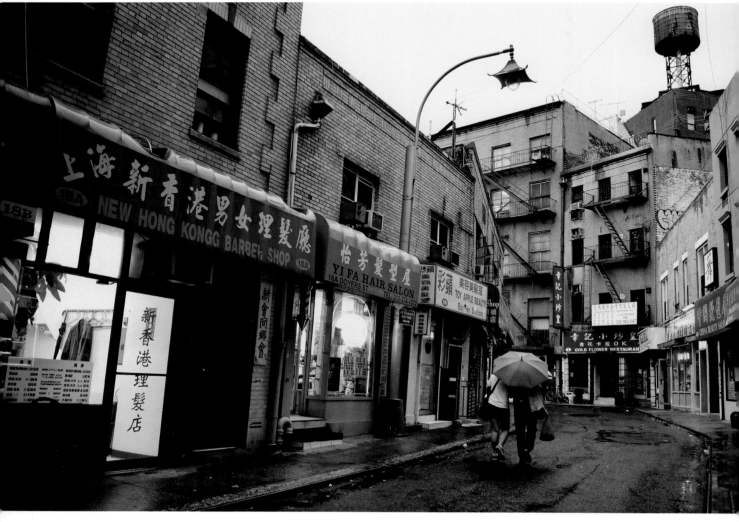

Doyers Street, Chinatown, Lower Manhattan
Sony SLT-A55V | f/4 | 1/40 second | ISO 200

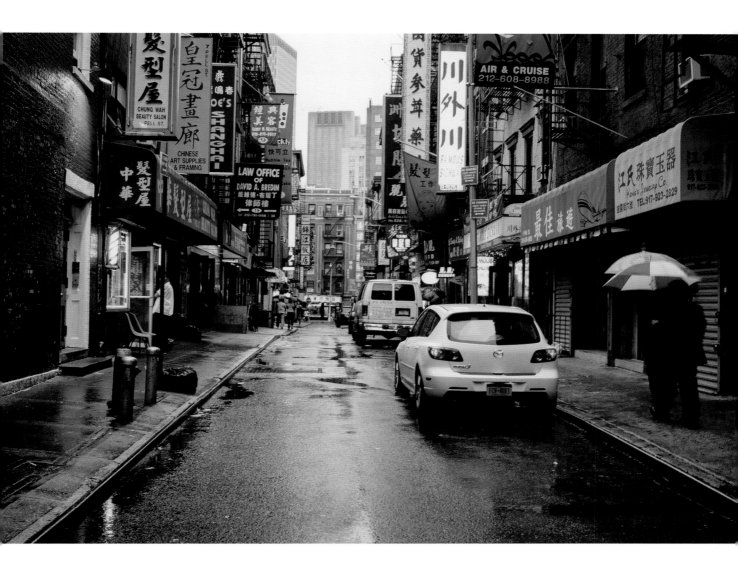

Pell Street, Chinatown, Lower Manhattan
Sony SLT-A55V | ƒ/4.0 | 1/30 second | ISO 200

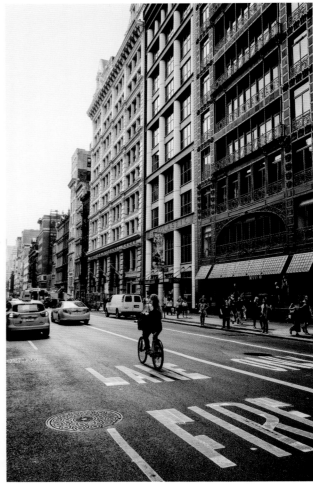

Soho, Lower Manhattan
Both photos: Sony DSC-QX100 and the iPhone 4S

Financial District, Lower Manhattan
Sony SLT-A55V | $f/4$ | 1/80 second | ISO 200

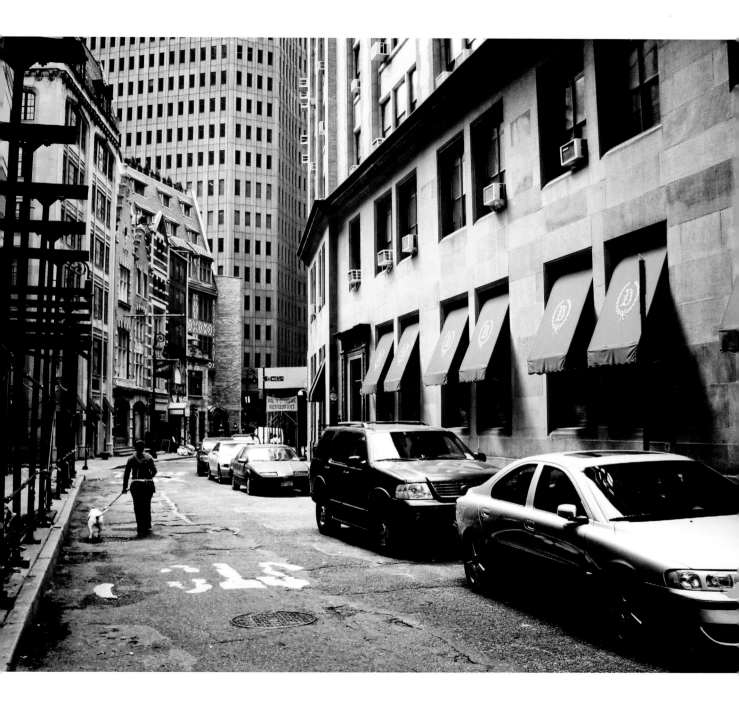

Midtown Manhattan
Sony NEX-6 | ƒ/2.2 | 1/100 second | ISO 100

Doyers Street, Chinatown, Lower Manhattan
Samsung ES15

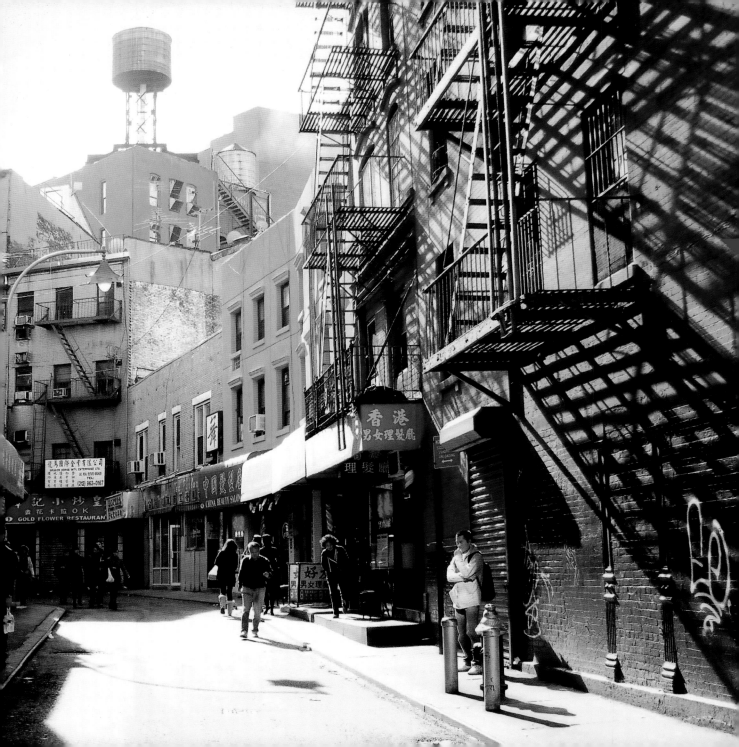

Rivington Street, Lower East Side, Lower Manhattan
iPhone 4S

There are moments that seem as if they have been transported from an entirely different era right into the heart of today. This is one of them. The gentleman sitting here in his three piece suit and fedora was casually enjoying his newspaper while sitting next to a few closed storefronts on a rather moody, overcast day.

When I first moved to the Lower East Side, I noticed the Botánica was only open for a few hours every day. A few of the neighbors in my apartment building who have lived here on the Lower East Side for decades would frequent the Botánica on a weekly basis. And as I got to know my neighbors, I understood how important their trips to the Botánica were for them, as they would make sure that they could shop there during the brief moments that the store was open.

A botánica is a retail store that sells folk medicine, religious candles and statuary, amulets, and other products regarded as magical or as alternative medicine. Some botánicas also carry incense, perfumes, and oils. While these stores are common in many Hispanic American countries and communities of Latino people elsewhere, botánicas can also be found in any United States city that has a sizable Latino/a population, particularly those with ties to the Caribbean.

The name "botánica" is Spanish and translates as "botany" or "plant" store, referring to these establishments' function as dispensaries of medicinal herbs. Medicinal herbs may be sold dried or fresh, prepackaged or in bulk. The stores almost always feature a variety of implements endemic to Roman Catholic religious practice, such as rosary beads, holy water, and images of saints. In addition, most have products associated with other spiritual practices such as candomblé, curanderismo, espiritismo, macumba, and santería.

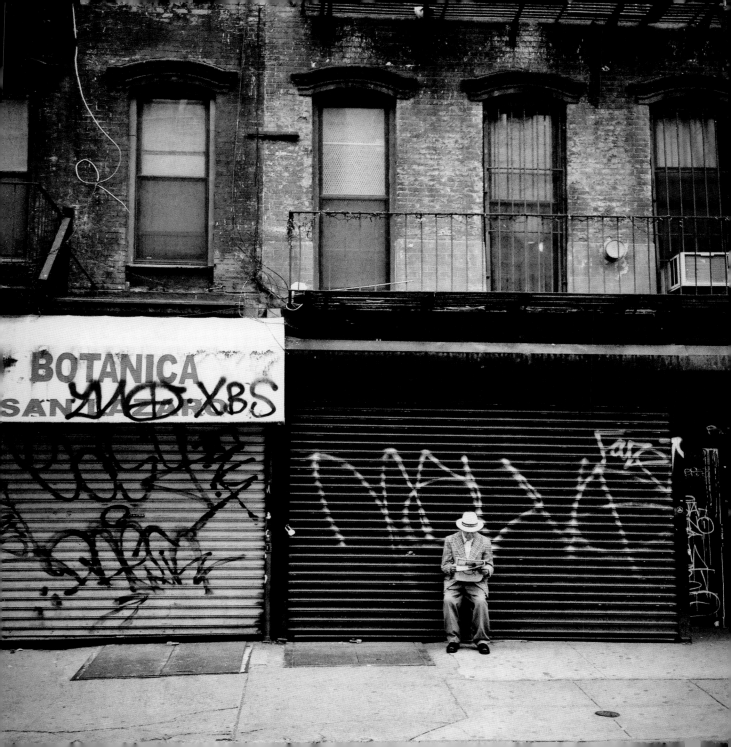

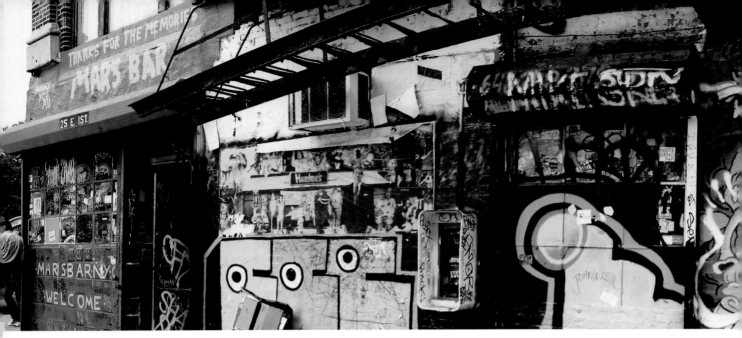

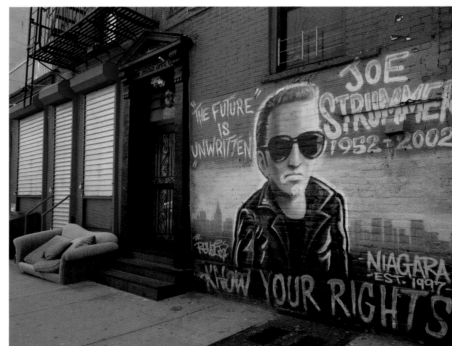

The East Village, Lower Manhattan
Panasonic Lumix FZ-35

The East Village, Lower Manhattan
Sony SLT-A55V | ƒ/4 | 1/60 second | ISO 200

The Lower East Side, Lower Manhattan
Sony SLT-A55V | ƒ/5 | 1/60 second | ISO 200

It's in the quiet still moments marked by emptiness, vast loneliness, and encroaching solitude that these peripheral dreamscapes come into focus.

These moments, suspended in time, marinate in the severity of their potential to eventually etch themselves into the eternity of the mind.

The rest of time moves with the rapid ebb and flow of life, like bits and pieces of paint on a wall chipping and peeling off, finally scattering like a discarded lover's flower petals in the wind.

Williamsburg, Brooklyn
Sony SLT-A55V | ƒ/5.6 | 1/60 second | ISO 200

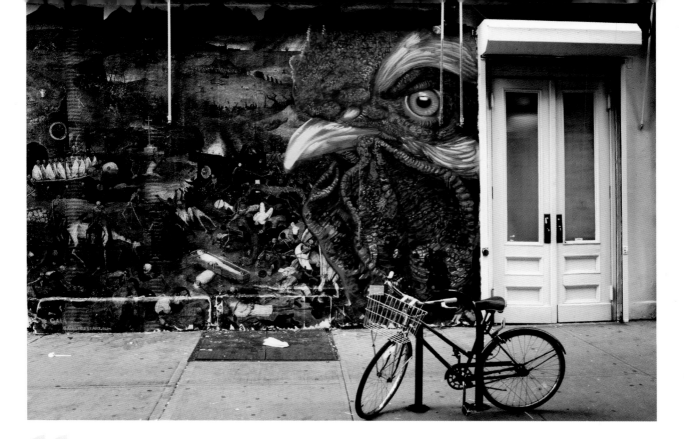

"

Through each scattered urban landscape
every sidewalk dream unfolds peripherally
as daily adventurers traverse the city full
of promise and silent giddy trepidation.

"

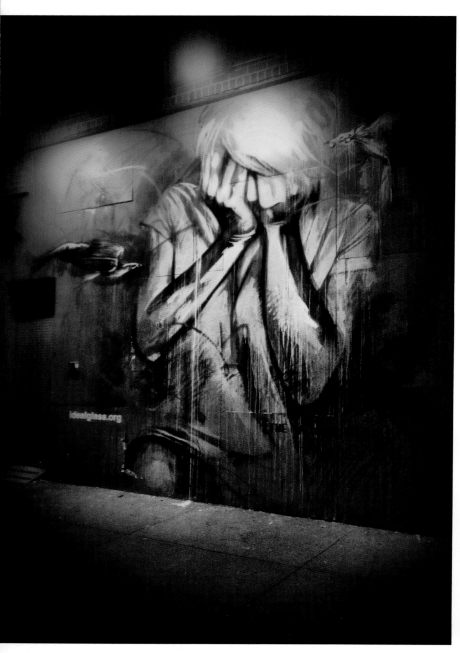

East Village, the Lower East Side, Lower Manhattan
iPhone 4S

Bushwick, Brooklyn
iPhone 4S

Soho, Lower Manhattan
iPhone 4S

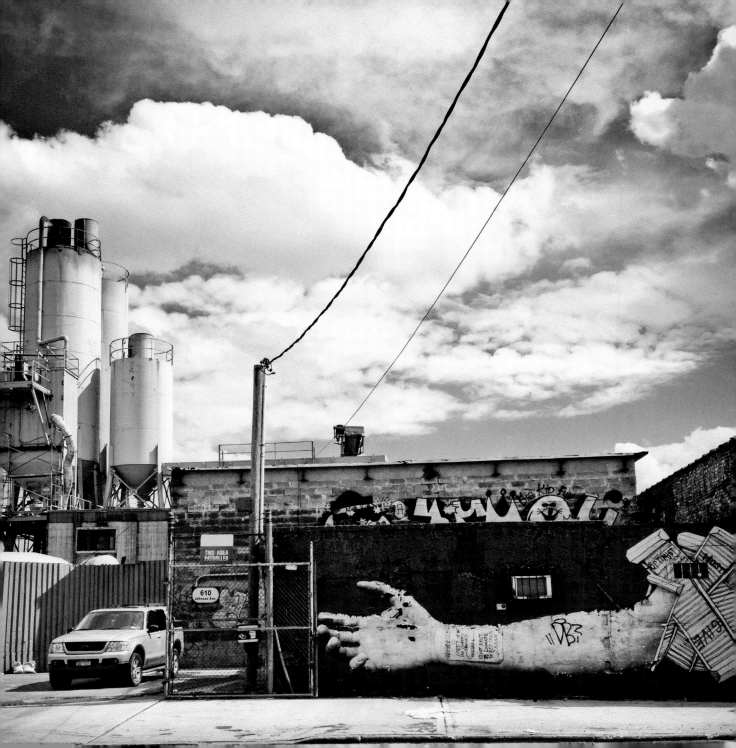

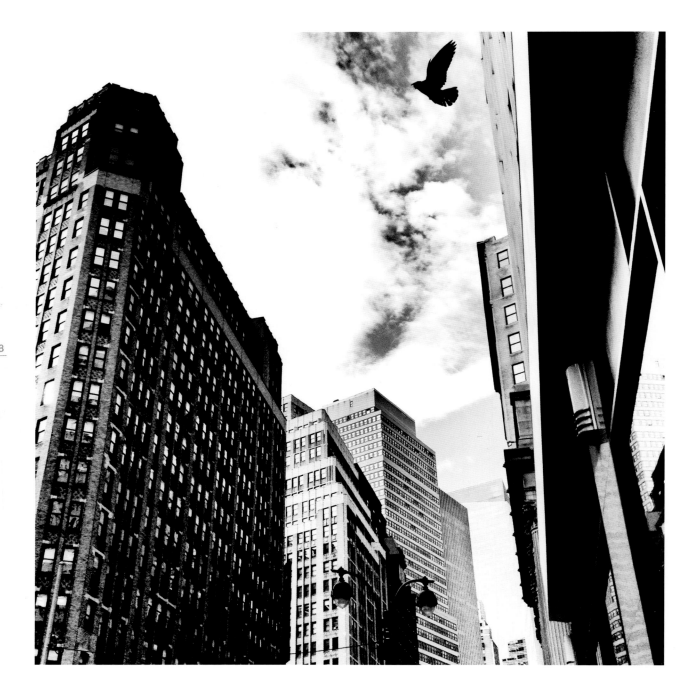

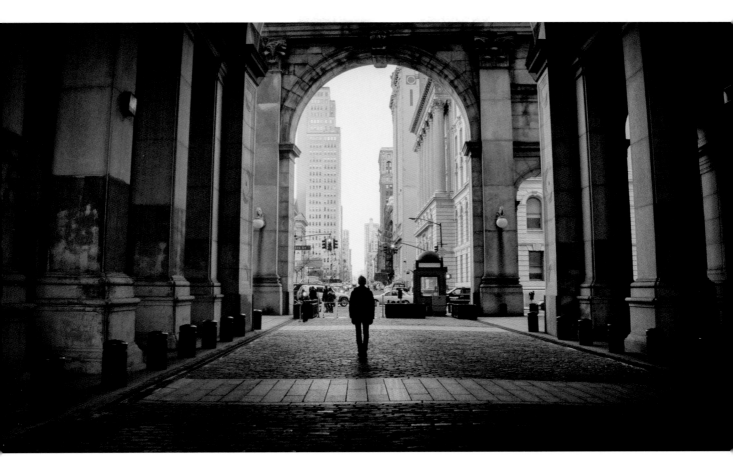

The Municipal Building, Lower Manhattan
Sony NEX-6 | ƒ/4.5 | 1/125 second | ISO 400

We move slowly towards the light over the cobblestones along the same paths that so many weary feet have passed before us; and through the archways and doors that sit in our immediate view, the city opens up like so many opportunities that sit ever so slightly out of our reach.

Midtown Manhattan
iPhone 4S

The Williamsburg Bridge
Sony SLT-A99V | ƒ/4.5 | 1/100 second | ISO 800

I look at this photo and I remember standing on the Williamsburg Bridge in the brisk winter cold with the wind whipping past my face. The stark afternoon sunlight moved behind a cover of bone-gray clouds and my heart was heavy because I felt like I had lost the light for the day. I had been meaning to photograph the sharp winter sun's light against the bridge's beautiful architecture. With my confidence shattered like the ice sheets that lined the bridge's walkway, I pondered putting my camera away.

And then, I distinctly remember pausing as the shadows fell before me perfectly cradling the bridge's structure, drawing the eye towards two distant silhouettes. It was an extreme shift in light and mood: one that I won't forget.

The memory of this photo reminds me of quote by French photographer Sarah Moon that resonates deeply:

"Time goes by. Light falls. I lose confidence. I don't want to be a photographer anymore...

"Then, all of a sudden, but not always, something changes, I can't say why, maybe I'm just in the right place at the right time, or maybe I believe in it.

"However, for a split second, I see a sparkle of beauty passing by, everything goes so quickly now within that stillness, and I'm carried away, and at last I like what I see, and I can't stop finding it, then losing it, and all day long I keep on, because it once existed." (This is an oral quote from a documentary series called *Contacts, Vol. 2: The Revival of Contemporary Photography*.)

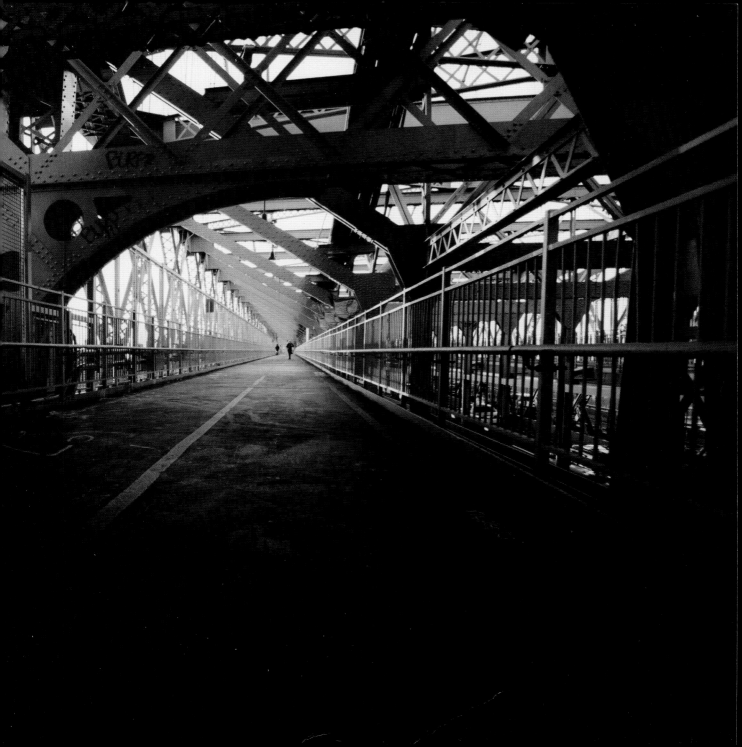

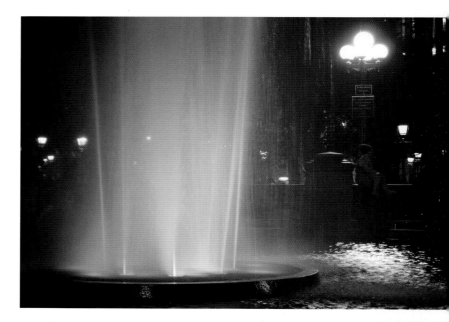

Washington Square Park Fountain,
Greenwich Village, Lower Manhattan
Sony SLT-A55V | ƒ/5.6 | 1/6 second | ISO 3200

What mood are you trying to evoke? How does the shooting style lend to the mood? Will black-and-white or color add to or take away from the mood? Once you have found the backdrop, how do you know who the candid stars of your photo will be? Do you have an idea of the type of person you want to fill the narrative, or do you take a variety of photos of various people walking by and then come up with a narrative later? Finally, when you look over your work after, how do you know which photo best represents all of the elements you were looking to capture? Is it a gut feeling or is there a precise method to figure out what works and what does not work?

When I shot the photo on the opposite page, I wanted to emphasize the way the cobblestones glistened in the summer heat and how beautiful the twinkling lights of oncoming cars were against the dark night. The car lights reminded me of fireflies. As I waited for the stars of the photo to walk into the scene, I couldn't help but think of how this photograph would be perfect in black-and-white.

Greenwich Village, Lower Manhattan
Sony SLT-A55V | ƒ/5.6 | 1/6 second | ISO 800

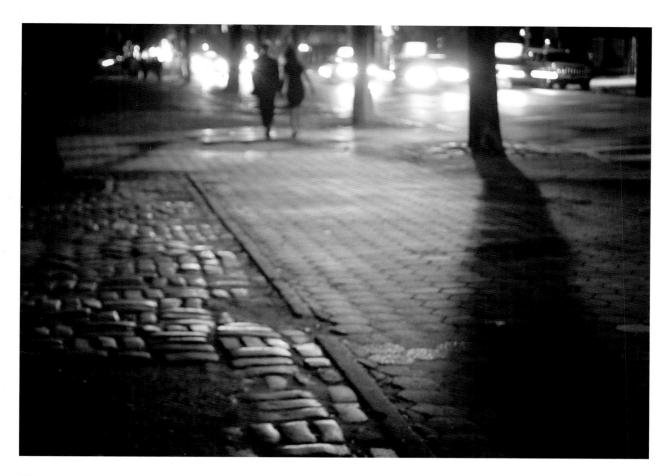

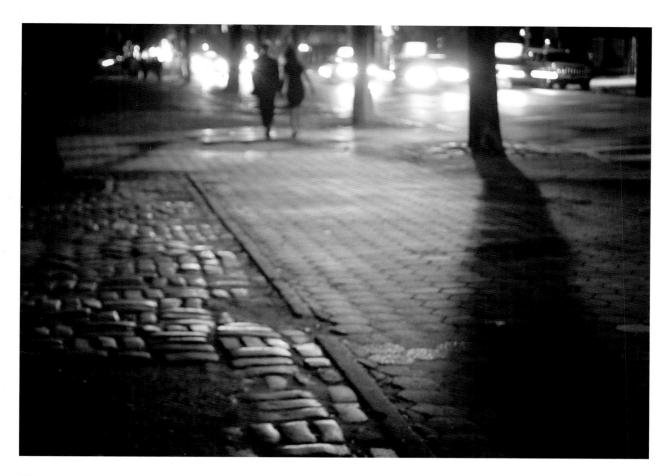

Central Park East, Upper Manhattan
Sony SLT-A55V | ƒ/5.6 | 1/5 second | ISO 3200

"

There is a series of decisions you go through
while conceptualizing and shooting street
photography. Some decisions are conscious
and others are subconscious, fueled by
influences and flights of imagination.

"

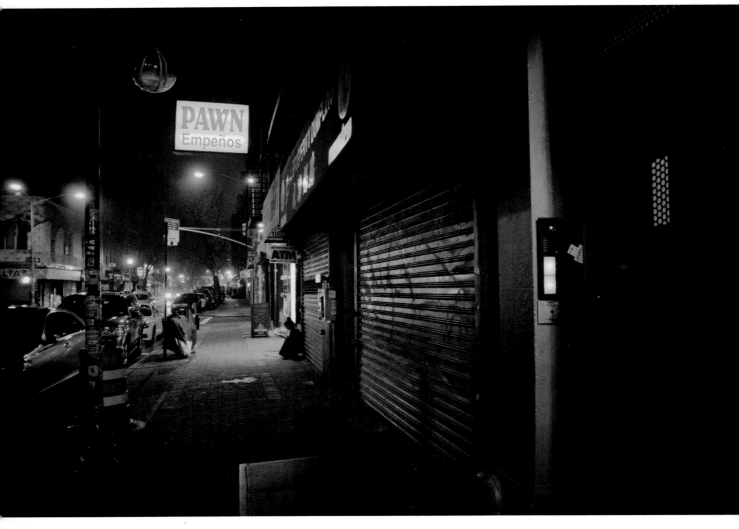

The Lower East Side, Lower Manhattan
Sony SLT-A99V | ƒ/4.5 | 1/50 second | ISO 3200

The Lower East Side, Lower Manhattan
Sony SLT-A99V | ƒ/4.5 | 1/30 second | ISO 3200

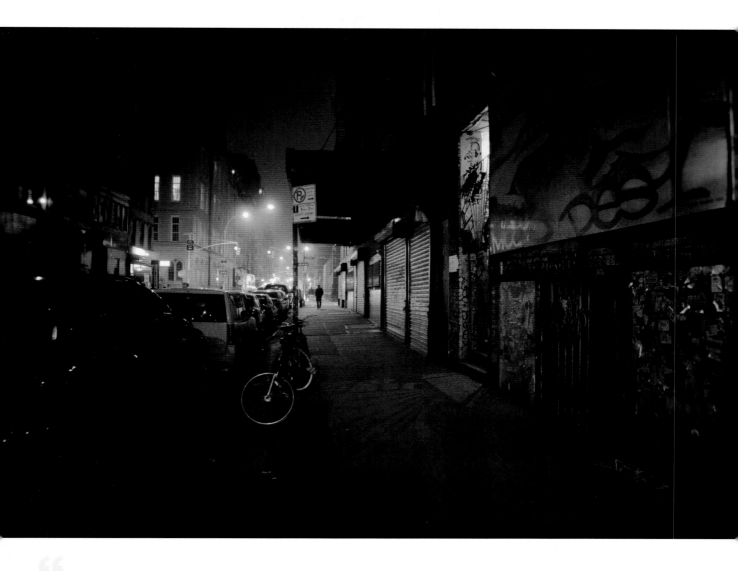

As street lights shine brightly under a blanket of darkness, the mist from the fog of millions of thoughts exhales at once into a sky heavy with dreams.

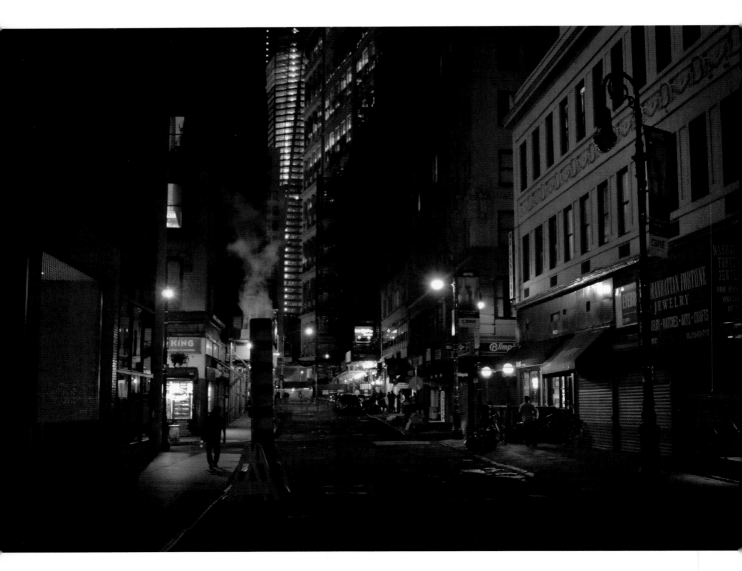

It's only after the multitudes have retreated to their homes away from the buildings and streets that hold them close during the day that the city relaxes, shaking the dust of the long day from its concrete limbs.

Street lights flicker like dream-heavy blinks of an eye, while smokestacks exhale world-weary breaths into the yawning night.

 The Financial District, Lower Manhattan
Sony SLT-A55V | f/5.6 | 1/40 second | ISO 800

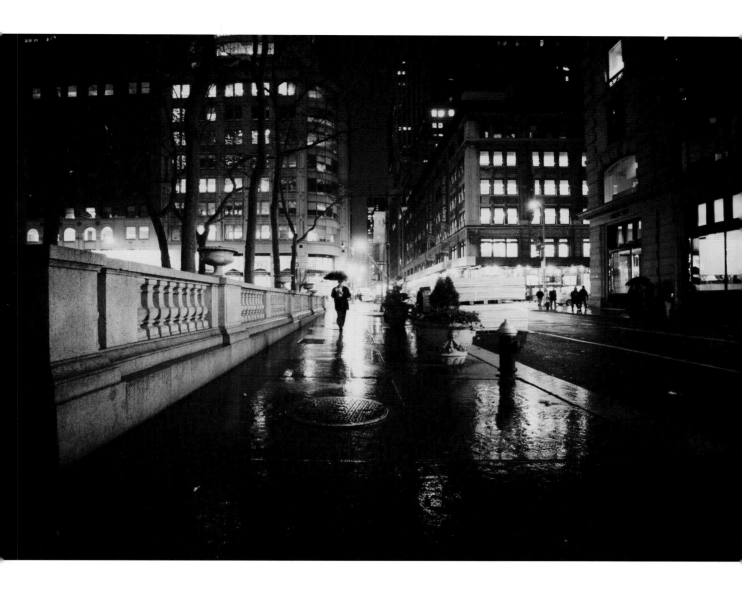

Midtown Manhattan
Sony SLT-A55V | ƒ/4 | 1/60 second | ISO 200

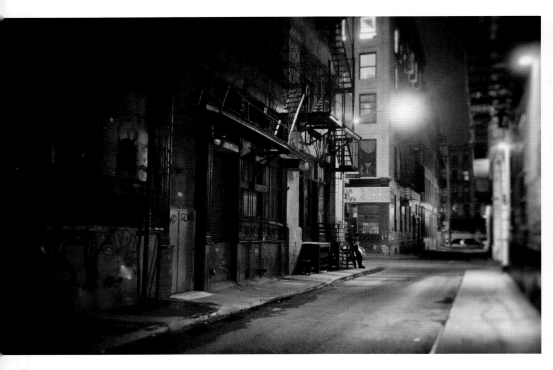

Chinatown, Lower Manhattan
Sony SLT-A99V | ƒ/2.8 | 1/80 second | ISO 4000

The Lower East Side, Lower Manhattan
Sony SLT-A55V | ƒ/5.6 | 1/4 second | ISO 400

"

When I initially took this image (right), I had constructed quite a few narratives in my mind about the scene, which was a random moment that I captured on a bitterly cold night on the Lower East Side a few winters back. The people were running down the alley because the wind-chill that night was below zero, and watching them run down an ice-lined dark alley created an intense sense of claustrophobic panic.

"

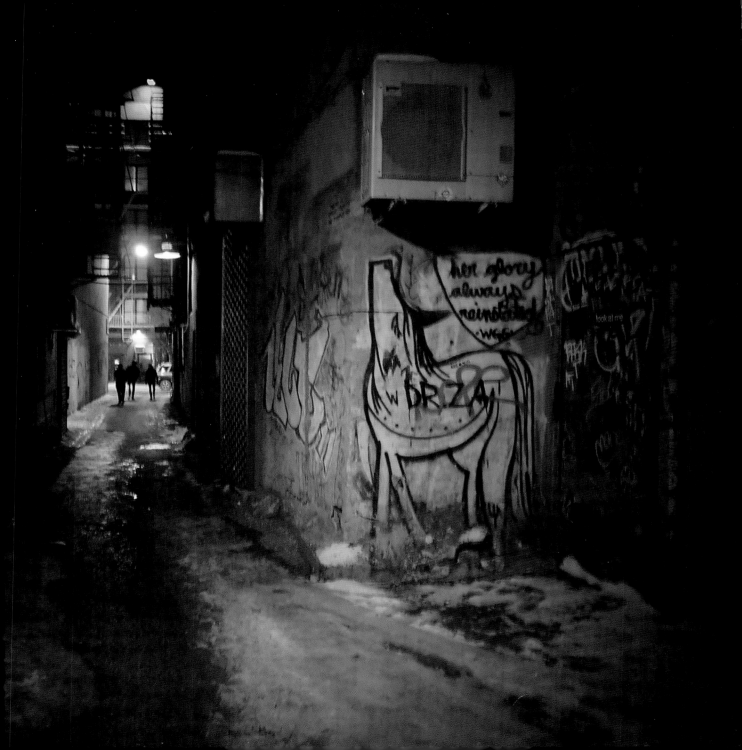

"

Some of my earliest memories of New York City nights involve elaborately lit signs and marquees. They always signified a host of exciting possibilities.

"

The East Village, Manhattan
iPhone 4S

The Lower East Side, Manhattan
Sony SLT-A55V | ƒ/5.6 | 1/40 second | ISO 800

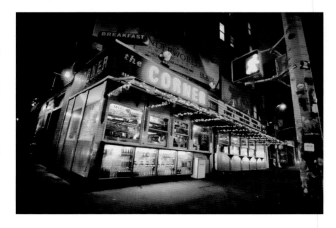

My first memories of the brilliantly lit Winter Garden Theater marquee (opposite) are from when I was eight or nine years old. My father worked nights as a pressman for the *Daily News*, which was located in the same area of Midtown Manhattan as this theater. I accompanied him a few times to the Daily News offices, and he would take me for a walk along Broadway where my eyes lit up wide with wonder at the sight of each and every theater's lights and marquees.

The Winter Garden Theater at the time was home to the musical *Cats*, and I would secretly hope that I could go see *Cats* one day every time we passed the glowing light of the theater marquee. I had the musical soundtrack at home and I played it repeatedly, and even taught myself several of the songs on piano. I never made it to *Cats* since Broadway theater outings were beyond the reach of my parents' humble budget.

My first Broadway show was *Starlight Express*, which I attended on a school trip. My ten-year-old self was totally enthralled with *Starlight Express*. It was hard not be enthralled by a musical that revolved around performers on roller skates and a child's train set that had magical properties. But I still remember unfairly comparing *Starlight Express* to *Cats*.

And yet my eyes still light up wide with wonder when I pass by the illuminated Winter Garden Theater sign.

Some things never change.

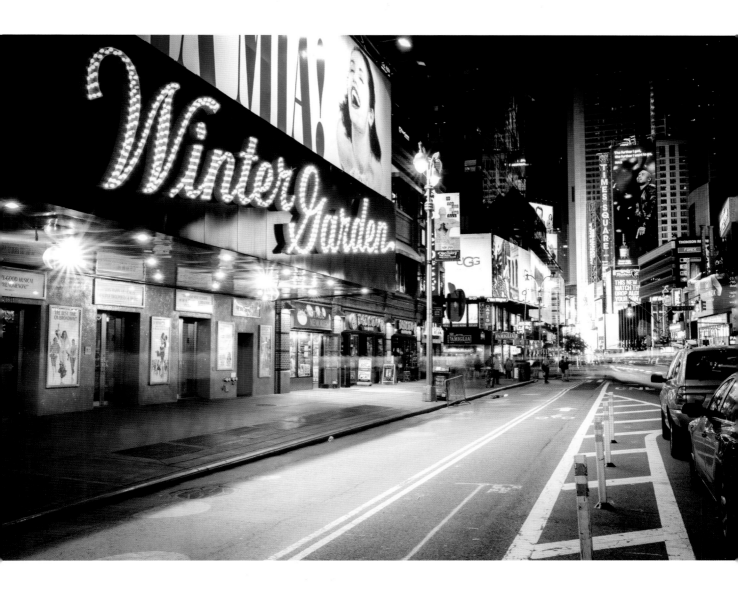

Midtown Manhattan
Sony SLT-A99V | f/13 | 8 seconds | ISO 50

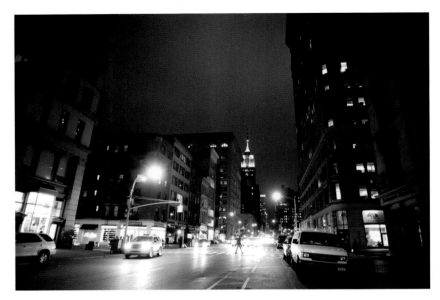

> "
> When days concede to night in the winter, there is a comfort in the glow of city lights. While neon lights can sometimes come across as cold, once the wind-chill dips into the single digits, those lights are also a sign of life. People tend to huddle under the glow of lights in the winter with a frequency that isn't seen in warmer months as if they are city moths, drawn to the promise of warmth.
> "

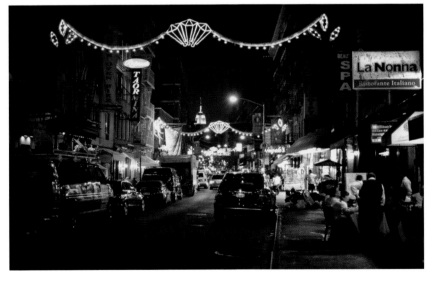

Little Italy, Lower Manhattan
Sony SLT-A55V | ƒ/5.6 | 1/40 second | ISO 400

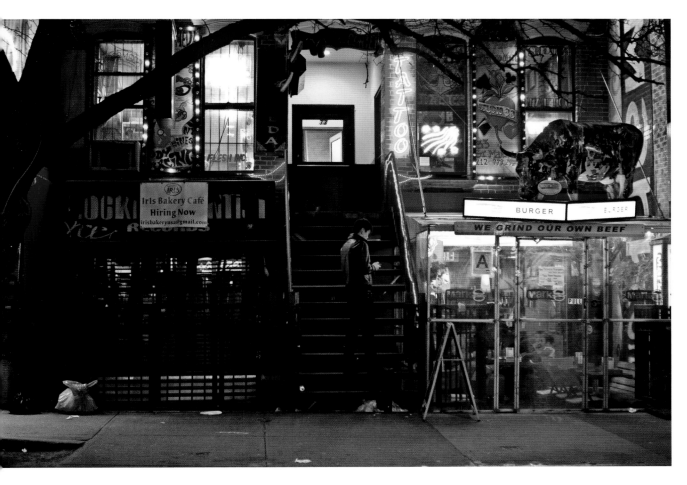

Street photography is a great way to observe these types of behavioral patterns. I often refer to street photography as a cinematic glimpse into a never-ending maze of pattern recognition. Once you are able to find the backdrop or set, the key is to wait for the star of the scene to show up and make the shot.

This happens to be one of my favorite sections of St. Mark's Place in Lower Manhattan (above). I have always been intrigued with how the eye is pulled from the interior of the restaurant on the lower-right, counter-clockwise up toward the giant cow sculpture, and around past the neon tattoo parlor signs toward the tree that frames the entire scene. In the winter, people often stop on the stairs to use the lights while they check their various mobile devices. And for tiny increments of time, they become the stars in this particular scene.

The East Village, Lower Manhattan
Sony SLT-A55V | ƒ/2.5 | 1/40 second | ISO 2500

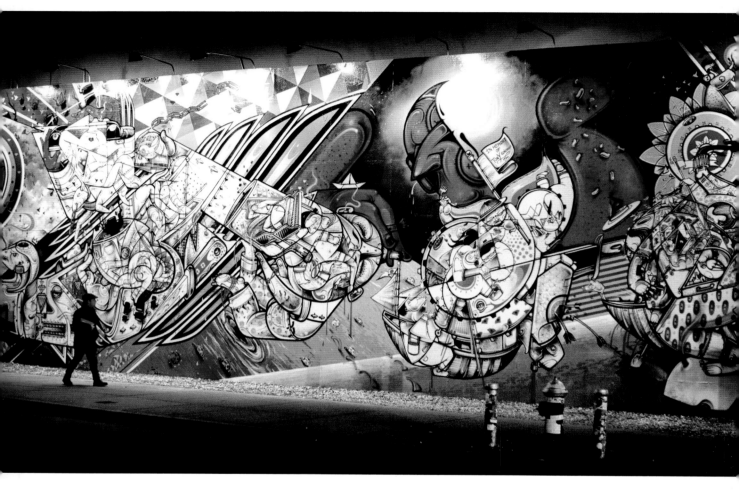

When I was really young, I used to imagine that at night in New York City, when the majority of people had gone to sleep, all the graffiti and the street art on the walls would come to life. Every figment of an artist's imagination, previously bound to the confines of a wall, would finally get to roam the city streets with abandon.

While reality is never quite as vivid as my imagination, the magic of photography keeps these sorts of dreams alive. Several times I have stood for a long time at night in front of this wall, waiting for the right person to come and breathe life into the scene.

The corner of Houston Street and the Bowery in Lower Manhattan
Sony SLT-A99V | f/2.5 | 1/80 second | ISO 2000

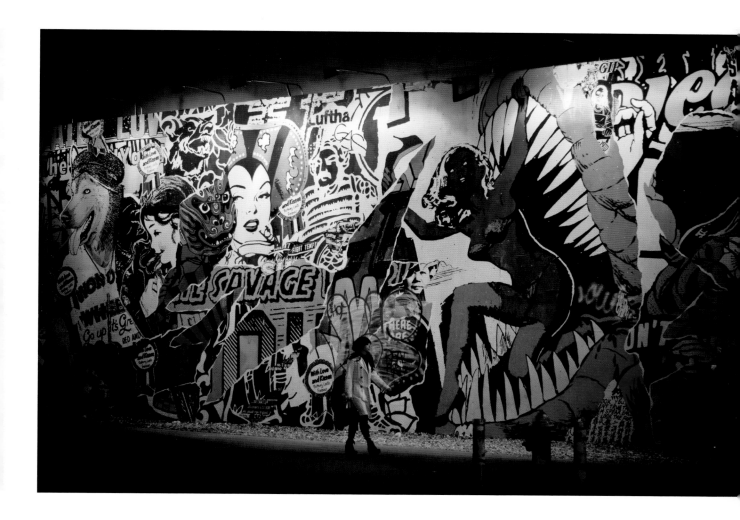

The corner of Houston Street and the Bowery
in Lower Manhattan
Sony SLT-A55V | ƒ/1.8 | 1/125 second | ISO 400

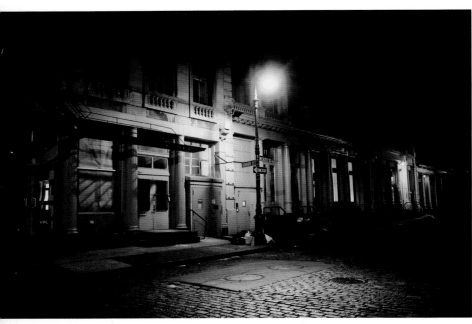

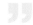 Soho, Lower Manhattan
Sony SLT-A55V | f/5.6 | 1/60 second | ISO 800

"

These city streets: at night
they pulsate through our
dreams, branching out like
dendrites, sending their
synaptic transmissions
into our collective memory.

"

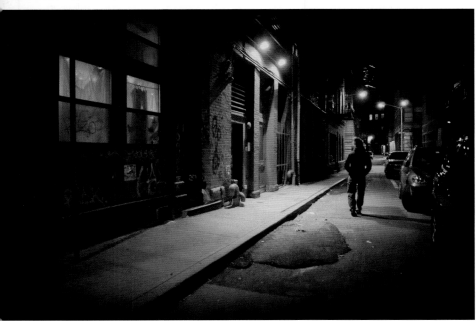

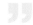 Tribeca, Lower Manhattan
Sony SLT-A55V | f/5.6 | 1/20 second | ISO 800

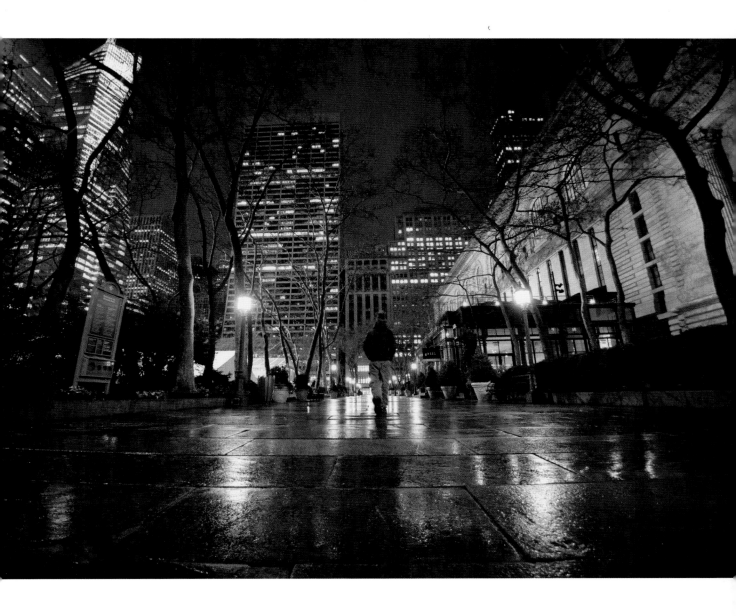

Bryant Park, Midtown Manhattan
Sony SLT-A99V | ƒ/4.5 | 1/25 second | ISO 4000

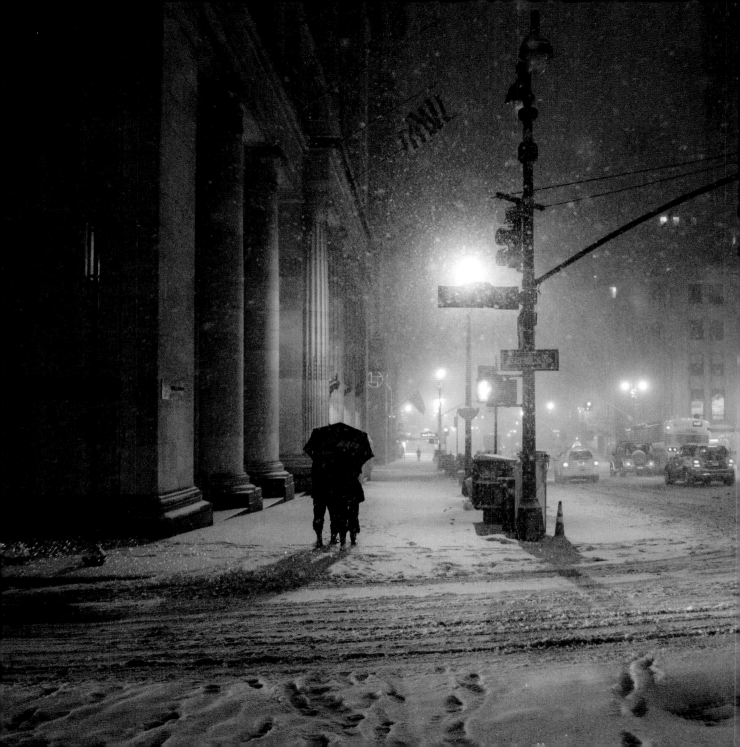

"

While winter photography can initially seem like a daunting idea, the results are usually well worth the effort. Of course, the best part of taking photographs in the winter is resting with a large mug of something delicious and hot after your photographic journey.

"

◀ Midtown Manhattan
Sony SLT-A99V | ƒ/4 | 1/125 second | ISO 4000

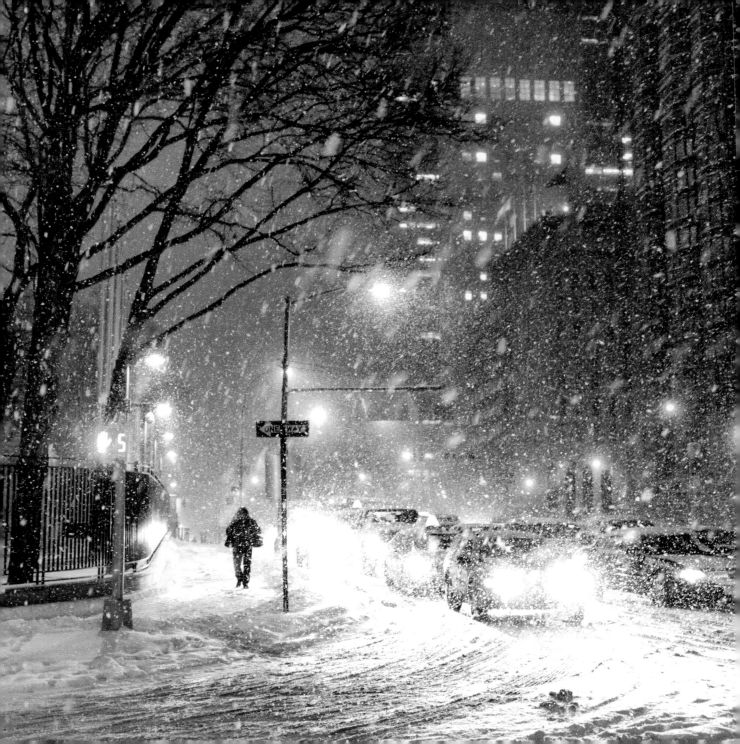

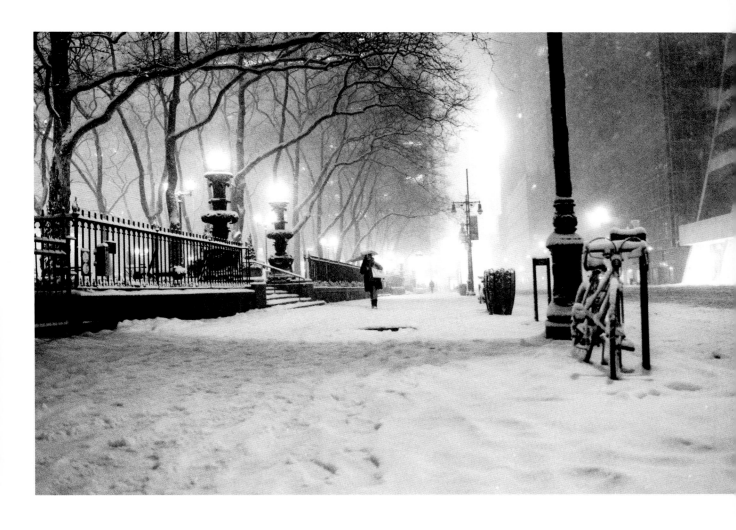

Midtown Manhattan
Sony SLT-A99V | ƒ/3.2 | 1/80 second | ISO 4000

Midtown Manhattan
Sony SLT-A99V | ƒ/4.5 | 1/80 second | ISO 4000

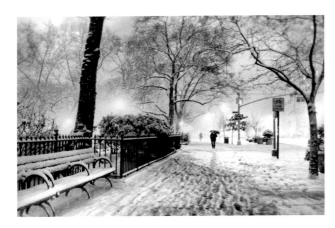

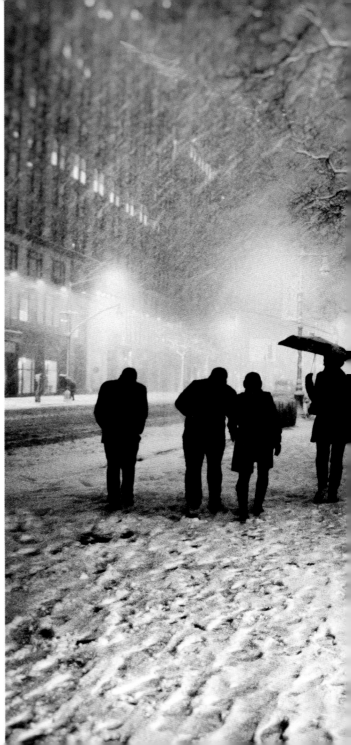

Madison Square Park, Midtown Manhattan
Sony SLT-A99V | ƒ/3.2 | 1/60 second | ISO 4000

Midtown Manhattan
Sony SLT-A99V | ƒ/3.2 | 1/125 second | ISO 4000

And we walk through the city
like somnambulists
moving through
an otherwordly landscape
gliding through
the white remnants
of dream-laden clouds
towards street lights
that hang over streets like stars.

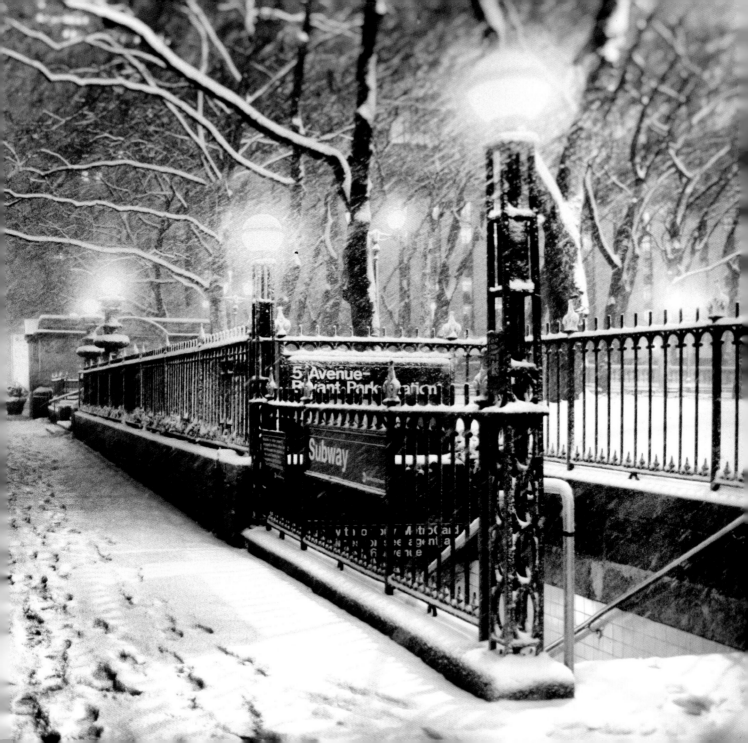

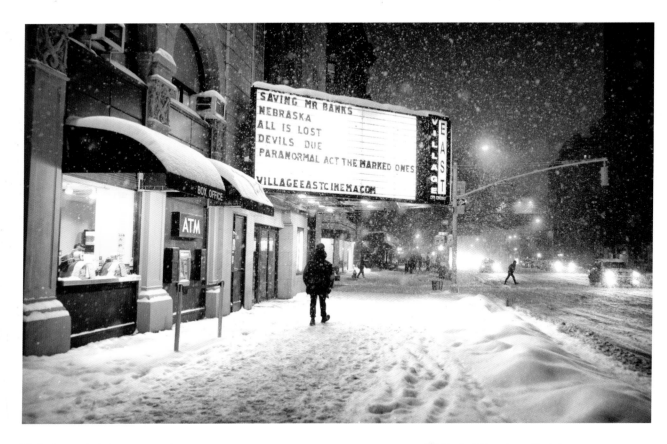

Winter nights are when

nostalgia wraps around you
like a blanket

as memories and longing

fill the air…

△ The East Village, Lower Manhattan
Sony SLT-A99V | ƒ/3.2 | 1/100 second | ISO 4000

▶ The East Village, Lower Manhattan
Sony SLT-A99V | ƒ/3.2 | 1/100 second | ISO 4000

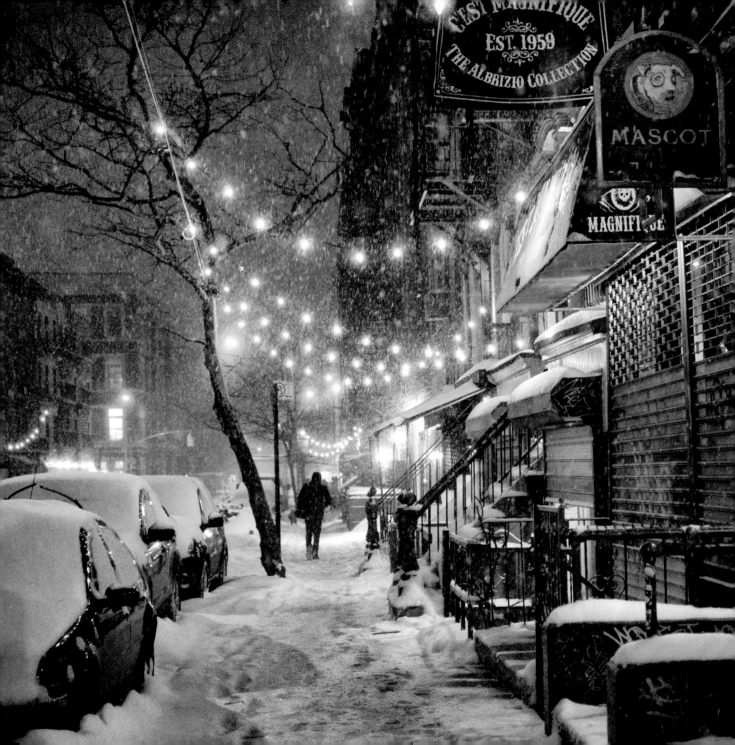

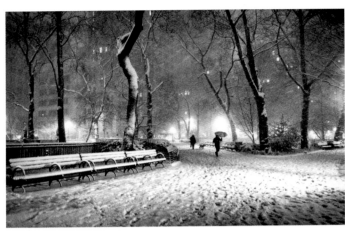

Madison Square Park, Midtown Manhattan
Sony SLT-A99V | *f*/2.8 | 1/30 second | ISO 4000

The New York City Public Library, Midtown Manhattan
Sony SLT-A99V | *f*/2.8 | 1/30 second | ISO 4000

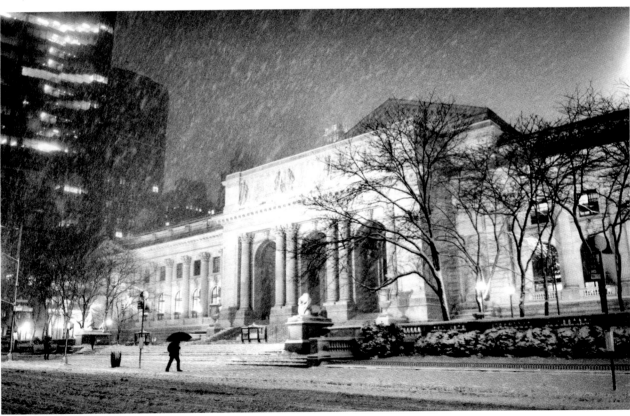

► Midtown Manhattan
Sony SLT-A99V | ƒ/3.2 | 1/40 second | ISO 4000

▼ Sutton Place, Midtown Manhattan
Sony SLT-A99V | ƒ/2.8 | 1/80 second | ISO 4000

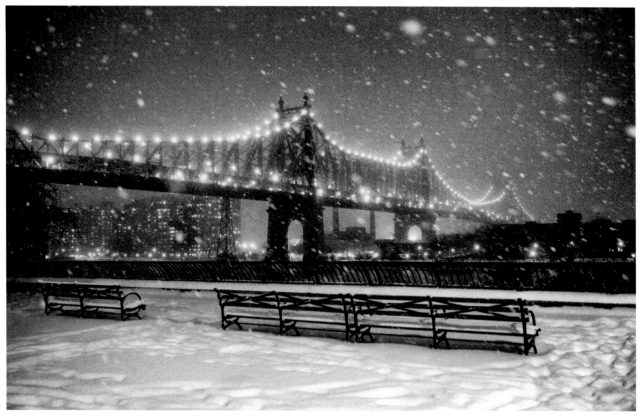

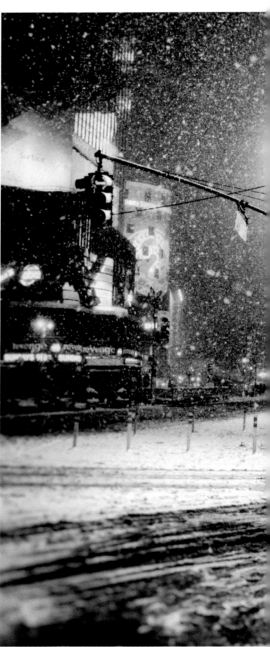

▽ ▽▽ Times Square, Midtown Manhattan
Sony SLT-A99V | *f*/3.2 | 1/100 second | ISO 2000

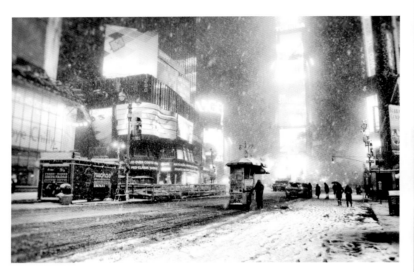

68

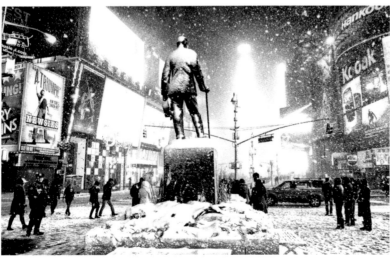

▶ Times Square, Midtown Manhattan
Sony SLT-A99V | *f*/3.2 | 1/60 second | ISO 2000

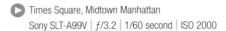

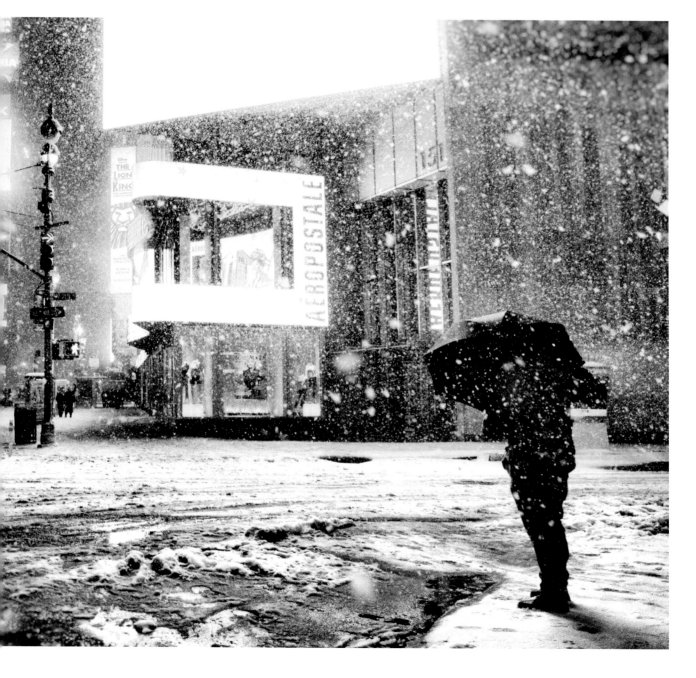

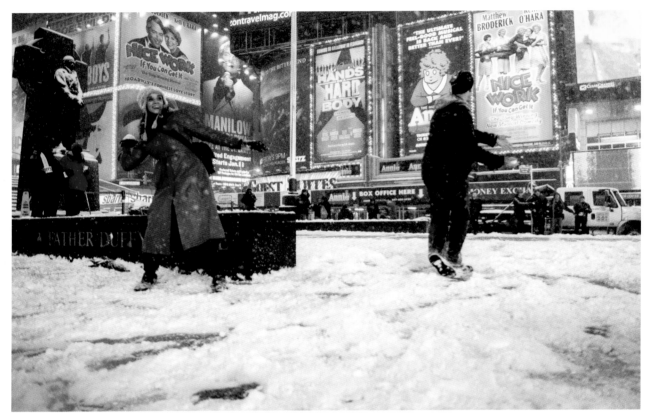

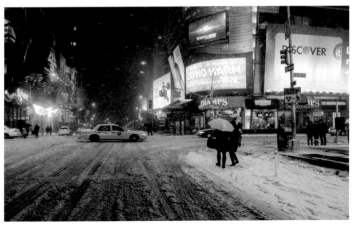

▲ Times Square, Midtown Manhattan
Sony SLT-A99V | ƒ/4.5 | 1/60 second | ISO 3200

◄ Times Square, Midtown Manhattan
Sony SLT-A99V | ƒ/7.1 | 1/250 second | ISO 3200

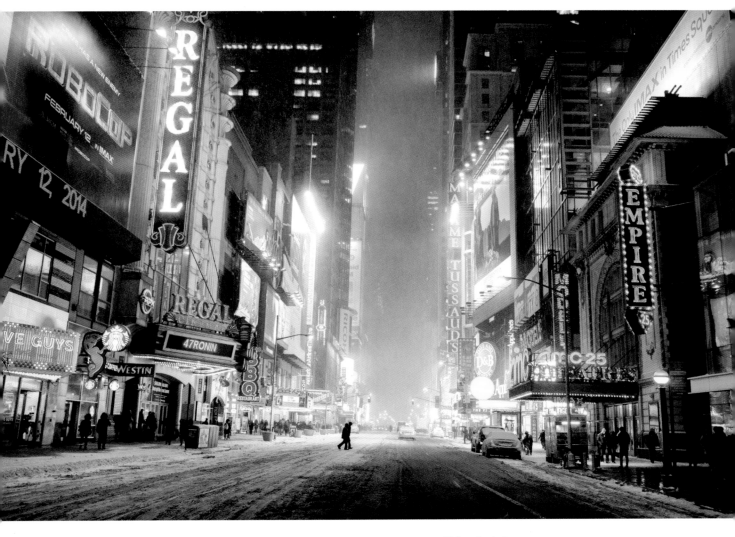

Times Square, Midtown Manhattan
Sony SLT | A55V | ƒ/4.0 | 1/60 second | ISO 200

City lights
flicker in the snow
and the night unfurls
into a fever-dream
cinematic sequence.

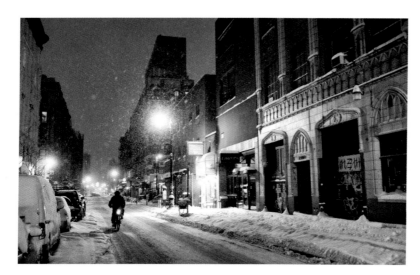

The Lower East Side, Lower Manhattan
Sony SLT-A99V | ƒ/3.2 | 1/60 second | ISO 4000

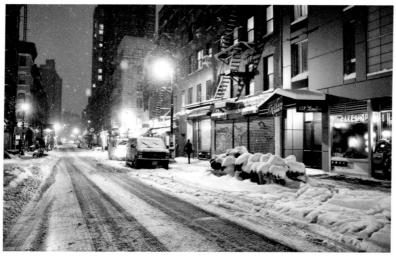

Times Square, Midtown Manhattan
Sony SLT-A99V | ƒ/3.2 | 1/80 second | ISO 4000

We wander
on winter nights
through streets
dusted with
the scattered remnants
of the sky's memories:
cloud debris
that cushions
the weight of hope
that bears down
on us
as we walk
with our faces turned
towards the city night's stars
that lead our way
into the melted light
of dreams.

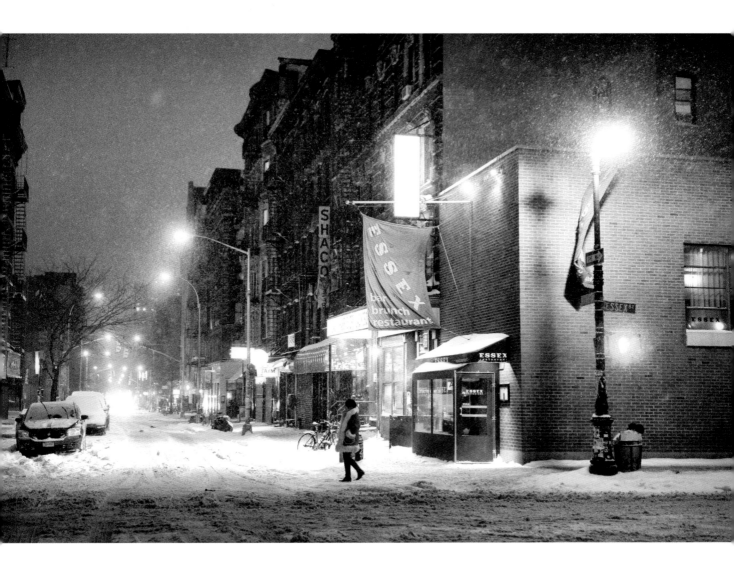

The Lower East Side, Lower Manhattan
Sony SLT-A99V | ƒ/3.2 | 1/80 second | ISO 4000

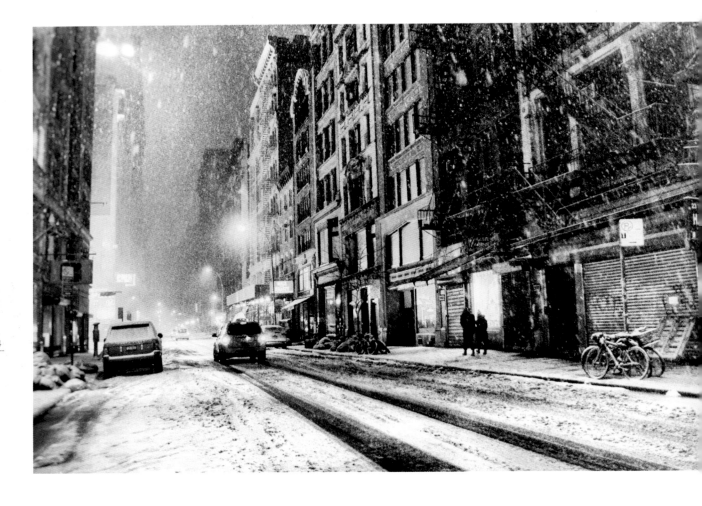

Union Square, Lower Manhattan
Sony SLT-A99V | ƒ/3.2 | 1/40 second | ISO 4000

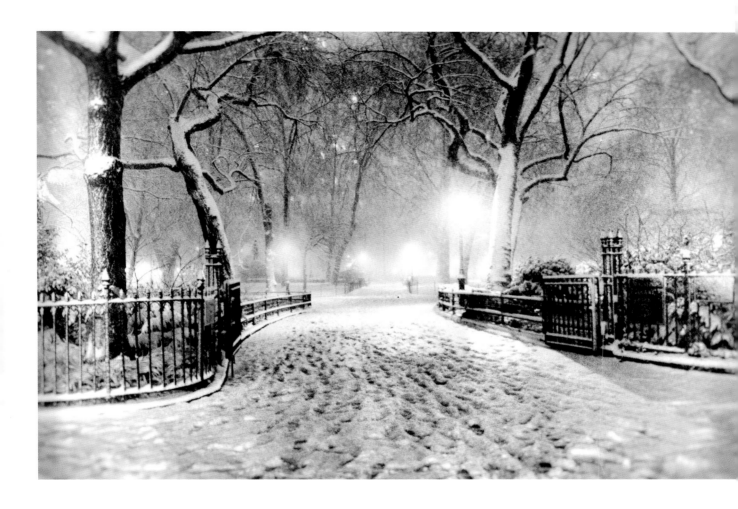

Madison Square Park, Midtown Manhattan
Sony SLT-A99V | *f*/3.2 | 1/60 second | ISO 4000

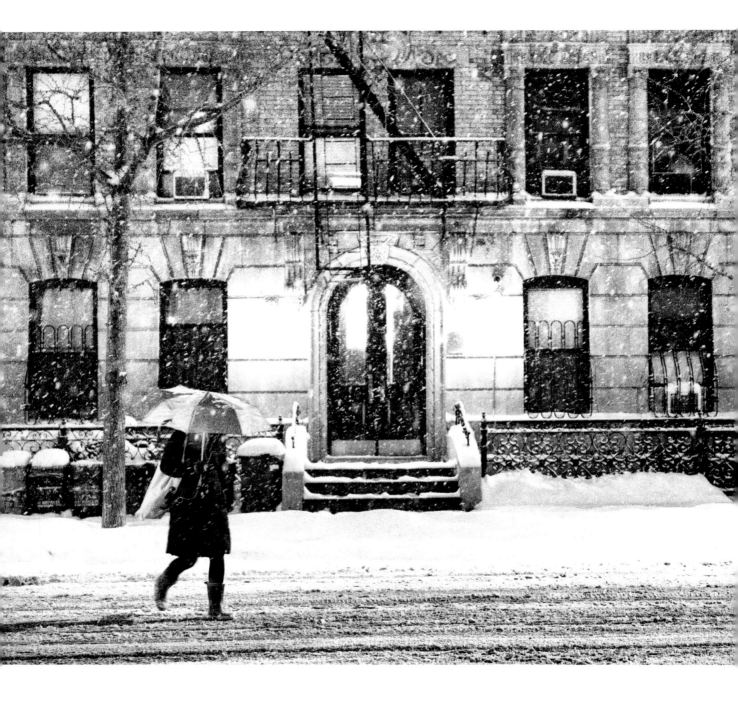

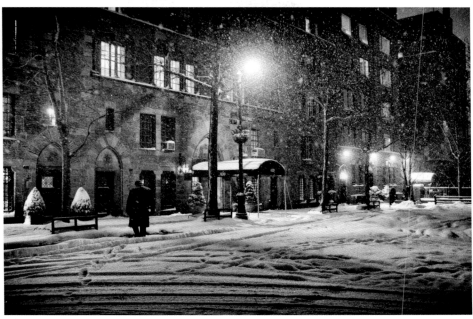

Sutton Place, Midtown Manhattan
Sony SLT-A99V | *f*/3.5 | 1/100 second | ISO 4000

It's quick.
The way darkness
falls when snow
blankets the streets.
And as the city
disappears
in a cavalcade of white
the night beckons
us home.

Sutton Place, Midtown Manhattan
Sony SLT-A99V | *f*/3.5 | 1/80 second | ISO 4000

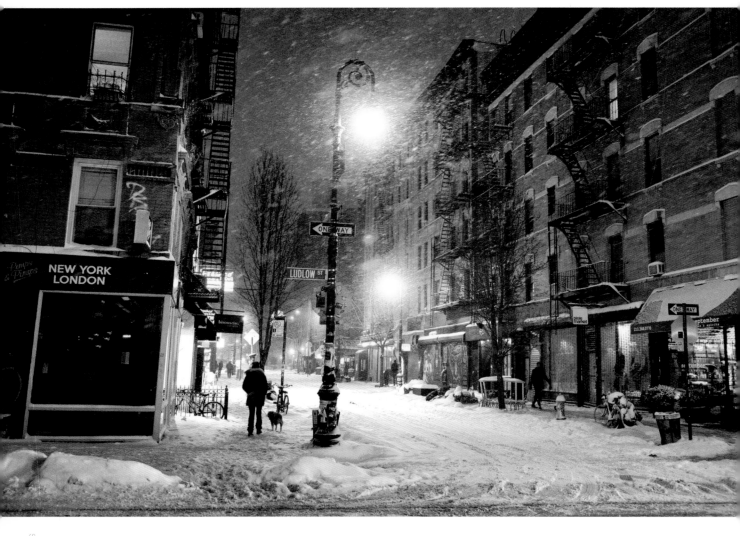

The Lower East Side, Lower Manhattan
Sony SLT-A99V | *f*/3.2 | 1/80 second | ISO 4000

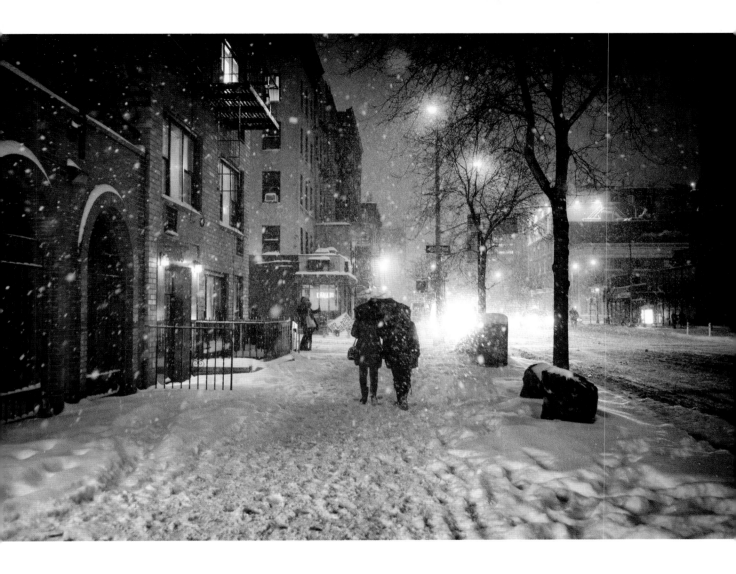

The East Village, Lower Manhattan
Sony SLT-A99V | *f*/3.2 | 1/100 second | ISO 4000

82

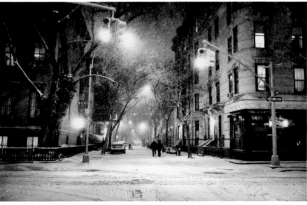

The West Village, Lower Manhattan
Sony SLT-A99V | ƒ/3.5 | 1/60 second | ISO 4000

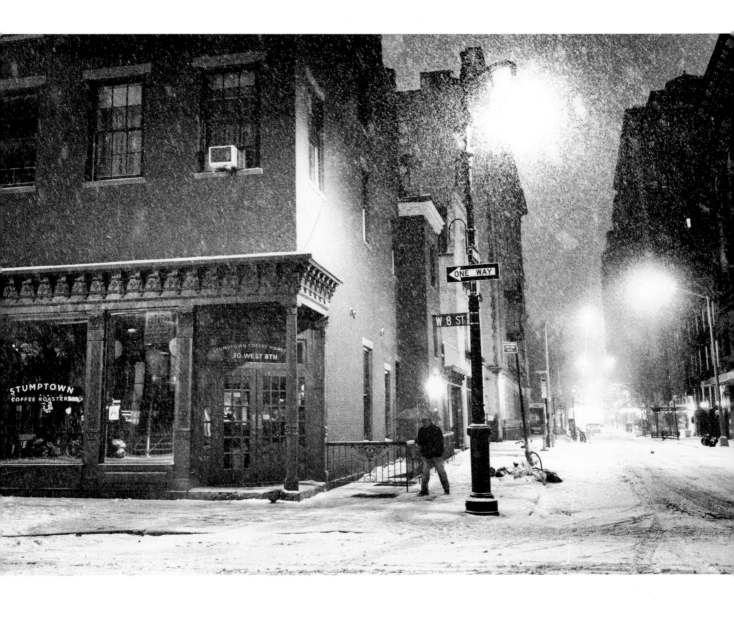

Greenwich Village, Lower Manhattan
Sony SLT-A99V | ƒ/3.5 | 1/80 second | ISO 4000

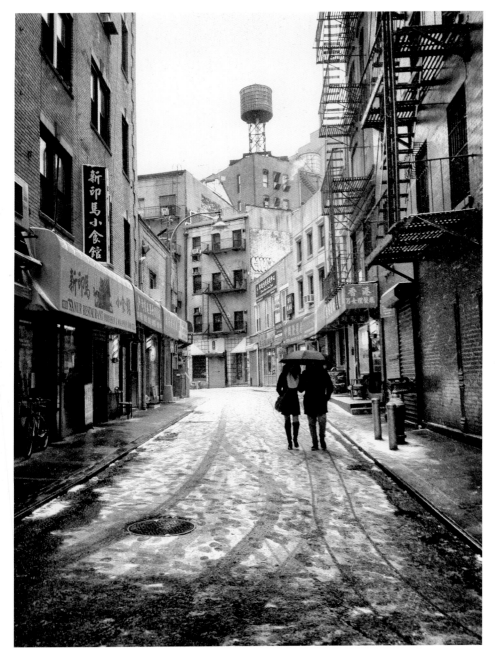

The snow fell
like icing sugar
onto streets
and alleys
that wrapped
themselves
around the city:
a sweet dusting
of white
on top of
glazed chocolate
concrete
that melted on
the tongue
of memory
like
a dream.

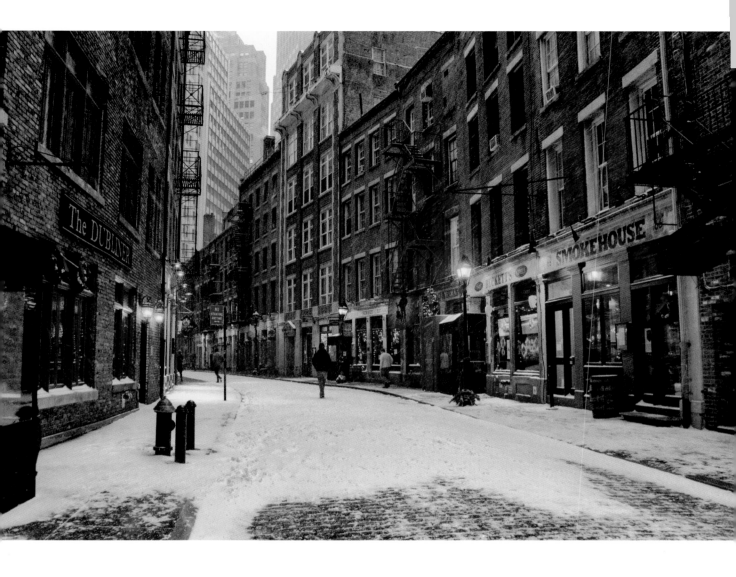

Doyers Street, Chinatown, Lower Manhattan
Sony NEX-6 | *f*/3.5 | 1/80 second | ISO 800

Stone Street, Financial District, Lower Manhattan
Sony NEX-6 | *f*/3.5 | 1/80 second | ISO 1600

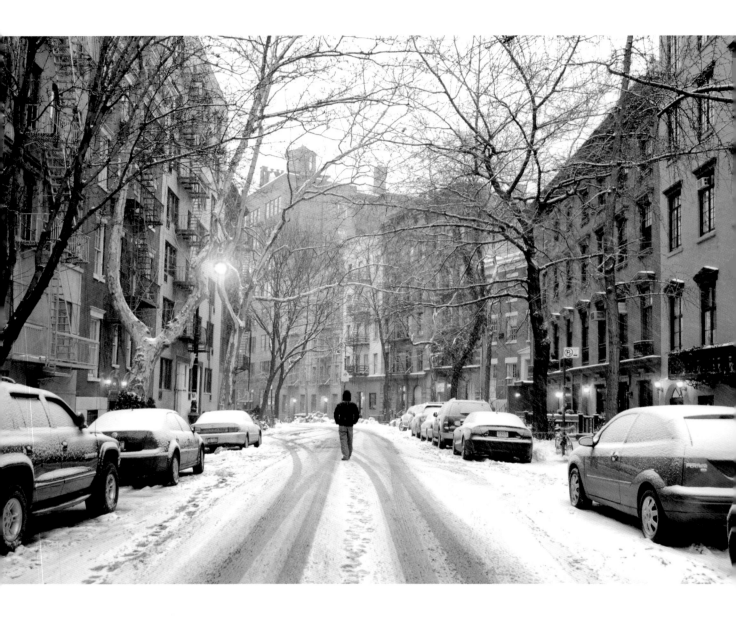

West Village, Lower Manhattan
Sony DSC-QX100 | ƒ/1.8 | 1/30 second | ISO 400

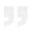
The East Village, Lower Manhattan
Sony SLT-A99V | ƒ/3.5 | 1/60 | ISO 4000

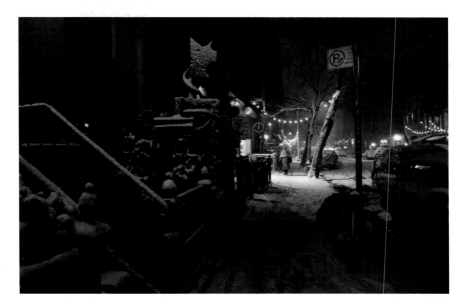

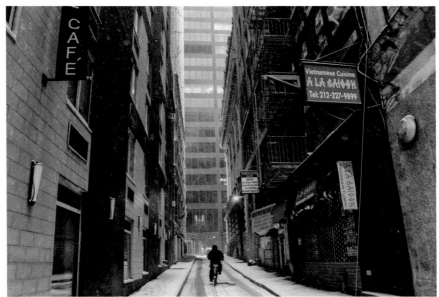

"

The street on the image left is Morton Street, which is home to some of the first land in New York City settled by the first wave of European immigrants. It's one of my favorite streets to walk down in the snow especially when all of the lights start to come on for the night.

"

The Financial District, Lower Manhattan
Sony NEX-6 | ƒ/3.5 | 1/60 second | ISO 400

| # SKYLINES

"

I have always been partial to late summer skyline views here in New York City. The haze that hangs over the horizon like a misty veil seems to lend a special sort of immediacy to the skyscrapers that assert themselves in the foreground.

"

Growing up in Queens, a borough of New York City, I was surrounded by a general attitude of contempt and disgust regarding anything tourist related. My father who worked nights as a newspaper pressman in Manhattan hated going into Manhattan for anything other than work, and my mother echoed the same prejudice toward "touristy things" in Manhattan as her outer-borough friends.

"The city" was something to be proud to live in close proximity to, but anything too popular in "the city" was the subject of eye-rolls. I grew up mimicking this sentiment. We would only ever go to places like Times Square and the Empire State Building when relatives or friends visited, and there was a silent stoicism adopted when "showing the sights" to "out-of-towners."

When I moved to Manhattan 11 years ago, I carried this attitude with me. It wasn't until I started taking photos that I fully opened my eyes.

When I finally discarded the jadedness that permeated my early years I started realizing how utterly phenomenal and fascinating all those touristy things really were. It may have taken me many years to fully grasp why people would come from all over the world to gaze lovingly at sights and architectural marvels like the Chrysler Building and the Empire State Building, but now it's hard not to gaze at these sights with anything but wonder.

The Chrysler Building, New York City's art deco masterpiece of architecture, always looks so regal positioned in front of the Ed Koch Queensboro Bridge (also known as the 59th Street Bridge). Four smokestacks playfully draw the eye towards the rest of Queens, which sprawls out in the distance towards the fading horizon.

It's as if the sky is locked in an embrace with the rest of the city while the skyscrapers that make up the Midtown Manhattan skyline are enraptured and wrapped up in their own special moment with the Chrysler Building.

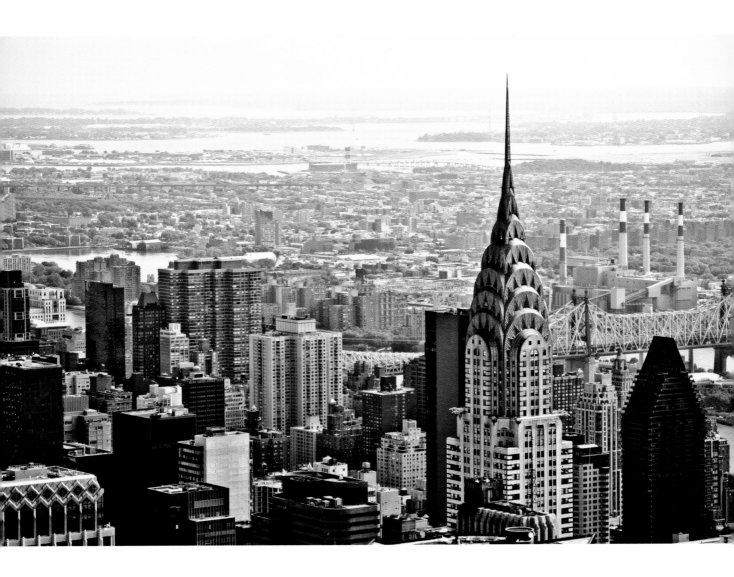

A view of the Chrysler Building and the Queensboro Bridge taken from the top of the Empire State Building

Sony SLT-A77 | f/5 | 1/60 second | ISO 100

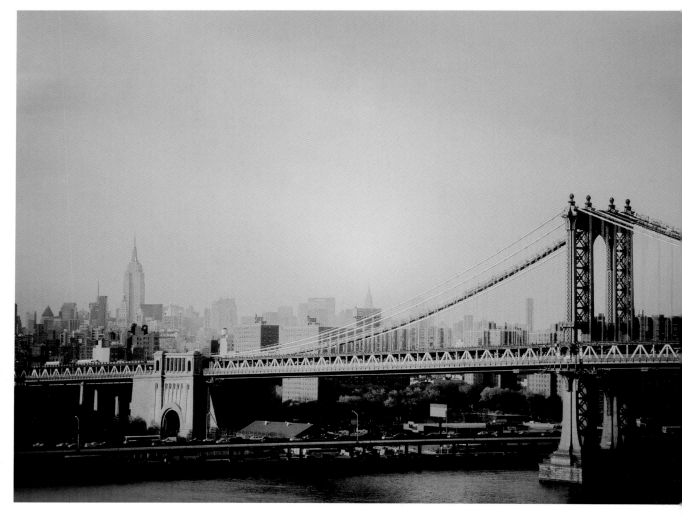

It had rained only an hour before I made my way across the Brooklyn Bridge, and as the sun started to set over New York City the storm clouds parted just enough to allow the most magnificent amount of sunlight wash over the Manhattan Bridge, which stood in the distance.

As the rest of the New York City skyline faded into the languid haze behind the majestic bridge I couldn't help but stare at it in amazement; it was as if nothing else mattered.

A view of the Manhattan Bridge taken from the Brooklyn Bridge
Sony SLT-A55V | ƒ/5.6 | 1/40 second | ISO 100

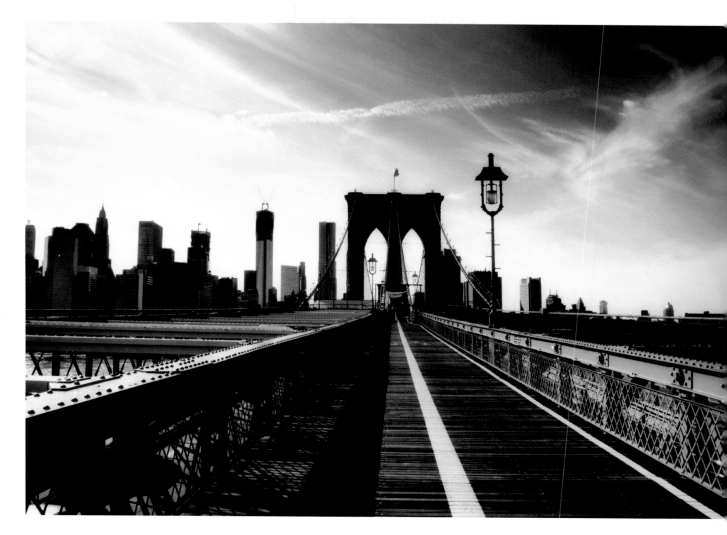

On hazy summer afternoons when dusk pulls its soft purple veil over the city, the skyline slowly softens in the dreamy-eyed gaze of the clouds.

And as light slides from the sky making its way over steel, wood, and concrete towards the disintegrating horizon, bridges and skyscrapers melt with the sun into the evening. The Brooklyn Bridge and New York City have been engaged in a reciprocal love affair for decades.

The Brooklyn Bridge
Sony SLT-A99V | ƒ/4 | 1/60 second | ISO 100

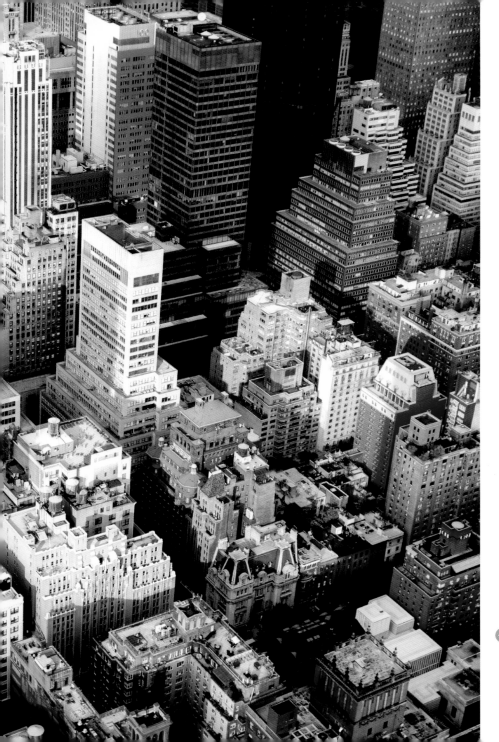

"
It's a city that either inspires flight or plants you firmly in its primordial schist formations, like the endless skyscrapers that rise up from such depths.
"

A view of the tops of Midtown Manhattan skyscrapers taken from the top of the Empire State Building
Sony DSC-QX100 | *f*/5 | 1/320 second | ISO 160

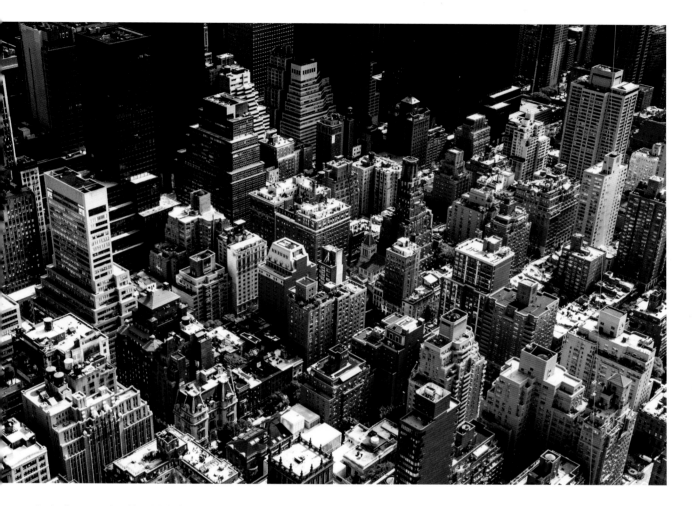

When you view New York City from above, it's hard not to get caught up in the heady rush that almost instantaneously occurs the moment your eyes attempt to account for the grandiose sense of the scale of the city.

How do you make sense of that split second when your heart beats in time to the rhythm of the streets below?

How do you keep your feet on the ground while your soul attempts to soar above and throughout the city, swooping between the cavernous buildings?

New York City is a study in contradictions and confirmations.

A view of the tops of Midtown Manhattan skyscrapers taken from the top of Rockefeller Center
Sony SLT-A77 | *f*/10 | 1/125 second | ISO 50

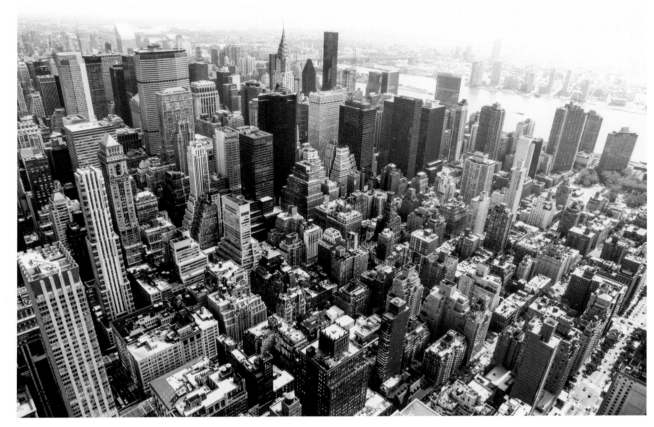

A view of Midtown Manhattan from above
taken from the top of the Empire State Building
Sony SLT-A77 | *f*/9 | 1/100 second | ISO 100

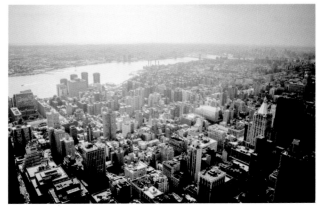

Where the winter brings a crystal sharp clarity to New York City, the summer seems to bring with it a gorgeous, bittersweet gauze-like haze that lifts during brief moments of direct sunlight in the afternoon hours. Summer sunlight in New York City clings to the ribs and heart like ethereal remnants of distant thoughts peeking their heads out of the sea of heat and humidity.

There is nothing quite like a
foggy day in New York City.

The sky slinks down
seductively towards the city

sending its clouds on
a romantic stroll through
the streets.

And the skyscrapers,

lost in the moment,

appear weightless
as they bubble over
in a heady rush
from all of the attention.

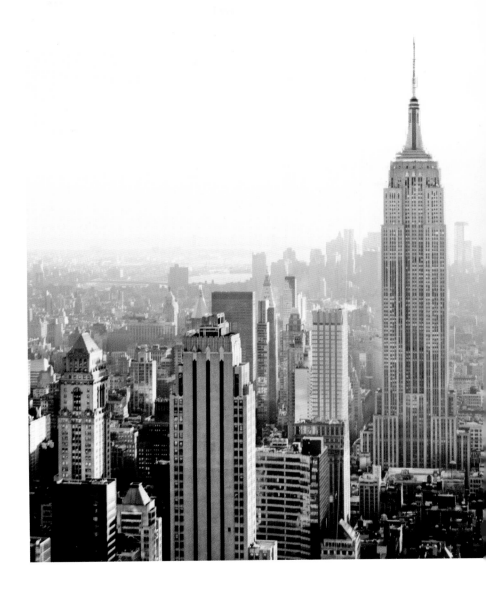

▶ A view of the Empire State Building taken
from the top of Rockefeller Center
Sony SLT-A99V | $f/9$ | 1/125 second | ISO 50

◀ A view of the Empire State Building
taken from the top of Rockefeller Center
Sony SLT-A77 | $f/7$ | 1/80 second | ISO 100

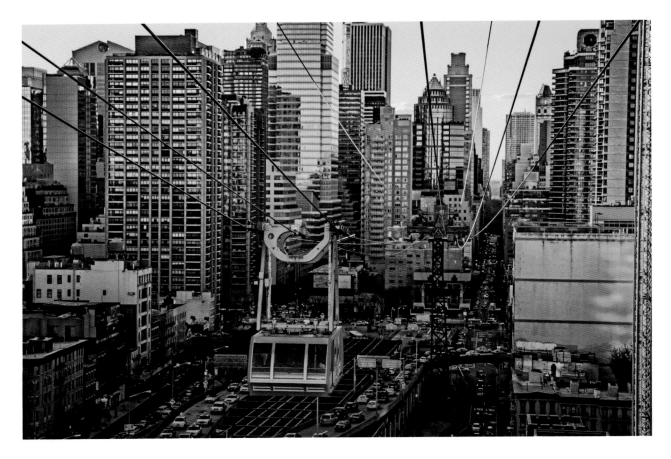

This photo was taken on the Roosevelt Island Tram in New York City. The Roosevelt Island Tram has been taking commuters from Manhattan to Roosevelt Island since the 1970s. It was completely renovated and modernized in 2010. Its highest point is 250 feet up in the air and it travels alongside the Queensboro Bridge above the East River. I have always referred to it lovingly as a slow amusement park ride in the middle of New York City. The views of Midtown Manhattan's skyscrapers as the tram car moves up and over the changing cityscape are breathtaking.

I think a lot about the moments that eventually become the still frame that resonates. On the day that I took this photo, I couldn't help but remember all of the times I wished I could fly when I was younger. When my tram car started its ascent, I knew that I needed to be ready for the moment that would make me feel the closest to my childhood dreams of flying. And as the adjacent tram moving in the opposite direction passed by, I was there to capture that moment forever.

The streets and rooftops of Midtown Manhattan taken from The Roosevelt Island Tram
Sony SLT-A99V | ƒ3.2 | 1/250 second | ISO 100

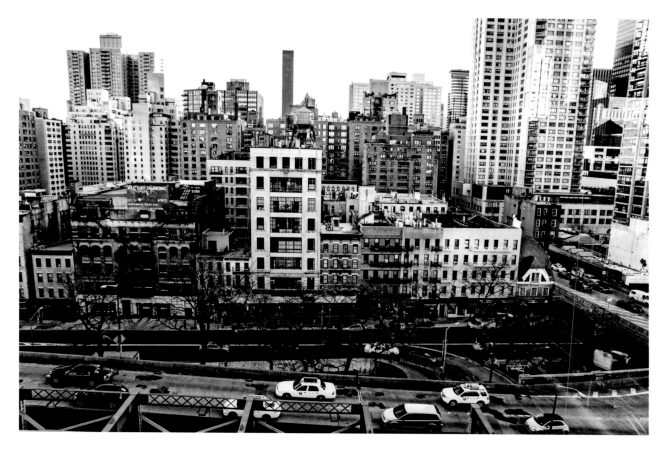

Despite wishing I could fly when I was younger, I have always been afraid of heights. It's partially a control issue and partially an irrational fear of the eternal "what if" quandary related to my own mortality. And yet, I have discovered as I get older that there is something supremely thrilling about being high up above things; especially being high up above New York City. It's the same scattered sense of adrenaline-fueled excitement that I get when I consider the vastness of the ocean. And in some ways, I think both vantage points offer the same sense of displaced wonder.

When I started to really fall in love with photographing New York City, I had such an incredibly visceral reaction when I experienced seeing the city from above the first few times I dared to get over my fear of heights. Despite the sweaty palms and

desire to cover my eyes, it was the moments when I let myself experience the beauty of being above the city that helped me to slowly embrace the vantage points of high places.

Once you take yourself out and away from the streets that surround you, it's as if the city opens up its arms to you. It's fascinating to consider all the activity and the stories that are contained in any one part of such a view.

The streets and rooftops of Midtown Manhattan taken from The Roosevelt Island Tram
Sony SLT-A99V | f2.8 | 1/160 second | ISO 200

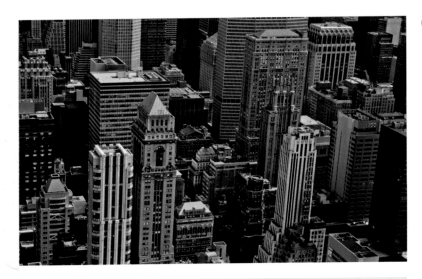

 A view of Midtown Manhattan skyscrapers
taken from the top of Rockefeller Center
Sony SLT-A77 | *f*/10 | 1/125 second | ISO 50

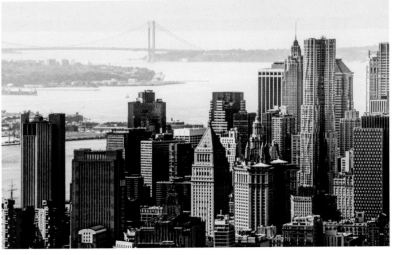

"
The city is comprised of
so many tiny urban worlds:
planets and stars that inhabit
a larger universe. Until I
understood that fact about
New York City, I couldn't
properly begin to understand
how to explore it.
"

A view of the Financial District skyline taken
from the top of the Empire State Building
Sony SLT-A77 | *f*/11 | 1/125 second | ISO 50

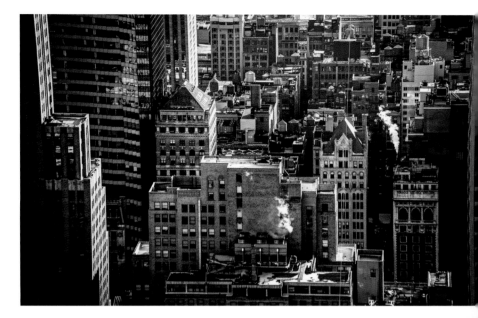

▶ The Midtown Manhattan skyline taken
from the top of Rockefeller Center
Sony SLT-A99V | ƒ/6.3 | 1/125 second | ISO 100

When you spend your days looking out of any number of windows in a city as large as this one, the urban world seems to shrink to include only the views that you are accustomed to seeing on a regular basis. Therefore, when you come across views that take you out of your small urban frame of reference and plant you outside of that view and outside of yourself for a few moments, it's a bit like finally coming to an understanding that the world you inhabit daily is just part of a larger picture.

And as your universe expands when you stand on a rooftop gazing out onto the planets and stars that populate its view, pieces of you can't help but expand along with it, and you are changed forever.

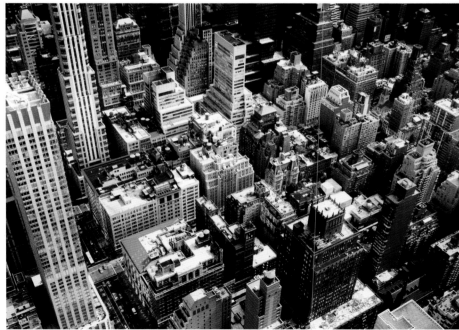

▶ The Midtown Manhattan skyline taken
from the top of Rockefeller Center
Sony SLT-A77 | ƒ/10 | 1/125 second | ISO 50

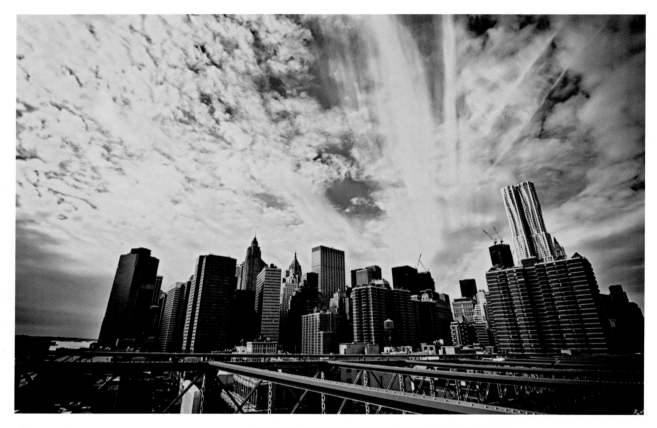

▲ The skyline of the Financial District
taken from the Brooklyn Bridge
Sony SLT-A55V │ ƒ/11 │ 1/200 second │ ISO 200

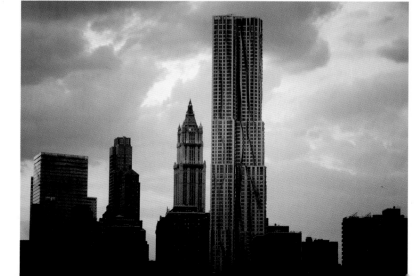

▶ The skyscrapers of Lower Manhattan
taken from Brooklyn Bridge Park, Brooklyn
Panasonic FZ35 │ ƒ/4 │ 1/200 second │ ISO 100

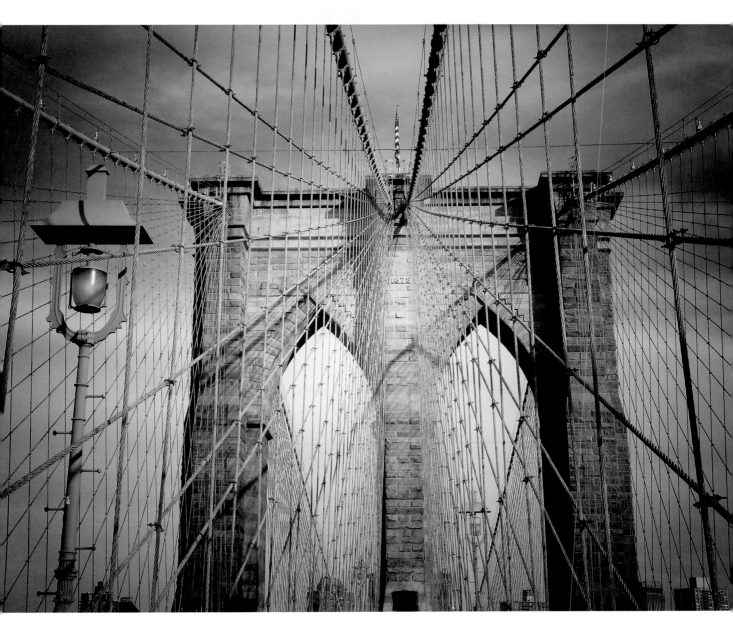

The Brooklyn Bridge
Panasonic FZ35 | ƒ/5.6 | 1/400 second | ISO 100

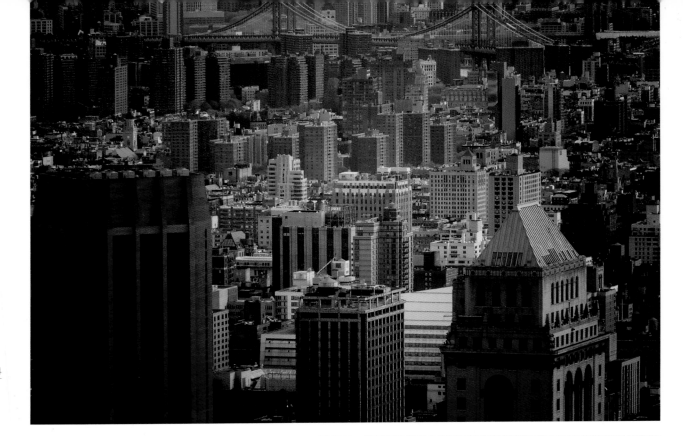

The skyscrapers of Midtown Manhattan
taken from the top of Rockefeller Center
Sony SLT-A55V | ƒ/5.6 | 1/125 second | ISO 100

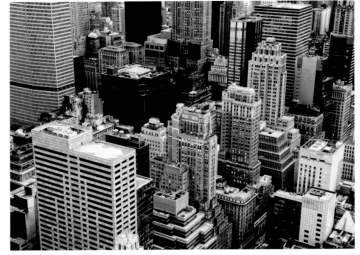

The skyscrapers of Midtown Manhattan
taken from the top of Rockefeller Center
Panasonic FZ35 | ƒ/4.5 | 1/250 second | ISO 100

> "
> The sun streams across the city in the evening touching every layer of the city with its warmth. And the streets, buildings, and bridges cling to its light with soft ferocity hoping to keep it from leaving the sky.
> "

The rooftops of Chinatown and the Brooklyn Bridge taken from the Manhattan Bridge
Sony SLT-A55V | $f/7$ | 1/80 second | ISO 100

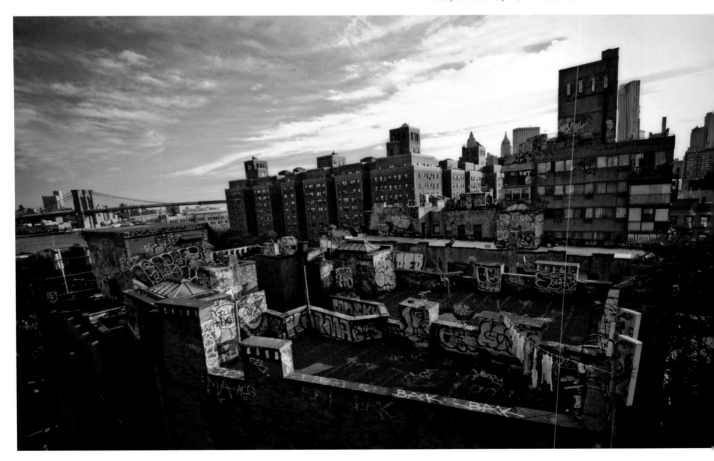

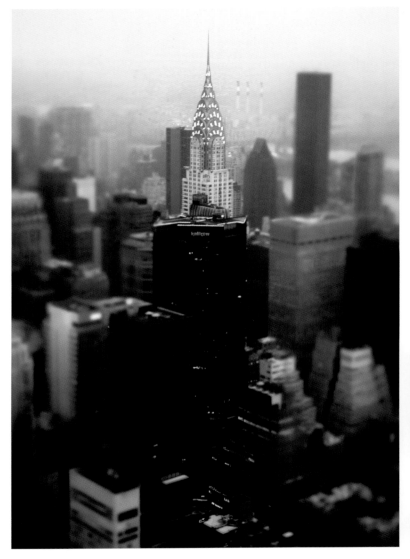

The Chrysler Building taken from
the top of the Empire State Building
Sony SLT-A99V | ƒ/2.8 | 1/6 second | ISO 50

"

If you wait for just the right
day, you can catch a glimpse
of the few moments during
sunset when the sun pries
the clouds open and lets
its light wash over the city
in waves.

"

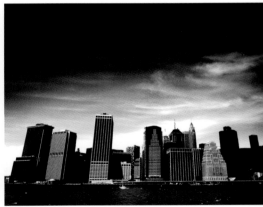

The skyline of Lower Manhattan taken
from Brooklyn Bridge Park, Brooklyn
Sony NEX-6 | ƒ/10 | 1/250 second | ISO 100

t's in the way the city rises up towards the sky conducting the
clouds and waves like a symphony. The crescendos are the loud
heartbeats of lovers and dreamers. And the diminuendos are the
whispers of hope uttered on soft breaths infused by the promise
of something greater.

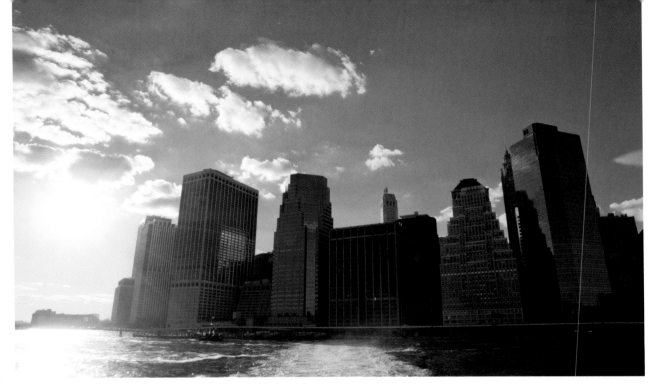

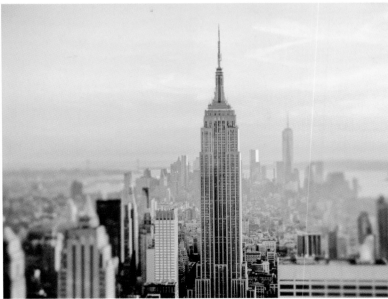

The skyline of Lower Manhattan
taken from the East River Ferry
Sony SLT-A77 | *f*/11 | 1/160 second | ISO 50

The Empire State Building taken
from the top of Rockefeller Center
Sony SLT-A99V | *f*/3.5 | 1/250 second | ISO 50

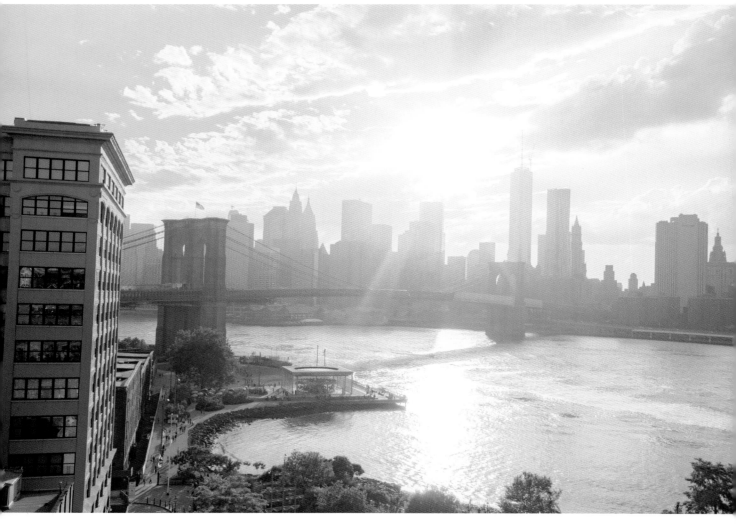

The Brooklyn Bridge and New York City
skyline taken from the Manhattan Bridge
Sony NEX-6 | ƒ/9 | 1/160 second | ISO 100

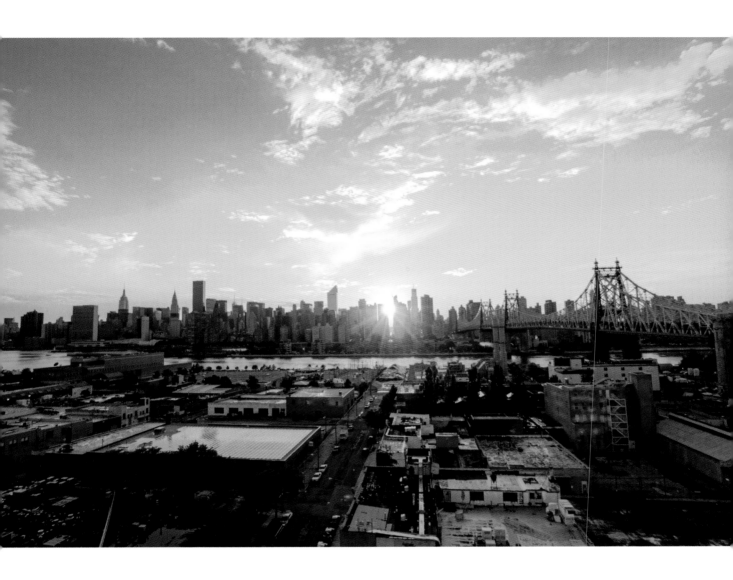

The skyline of Midtown Manhattan and the Queensboro
Bridge taken from a rooftop in Long Island City, Queens
Sony SLT-A99V | f/9 | 1/25 second | ISO 50

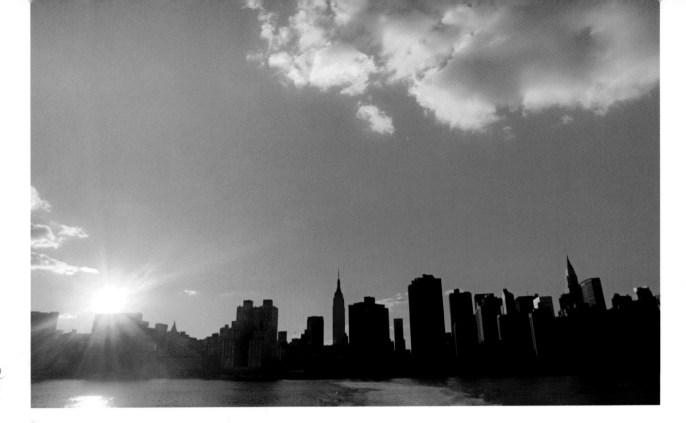

"

Before the night trails across the sky leaving darkness and whispers in its wake, the sun melts over the city's towering silhouettes pouring its essence into the water like liquid gold.

The city lights illuminate the urban landscape like stars while every last ember of daylight fades: extinguished sparks exhaled in the long sighs of evening wanderers.

"

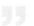 The skyline of Midtown Manhattan taken from the East River Ferry
Sony SLT-A77 | f/11 | 1/150 second | ISO 50

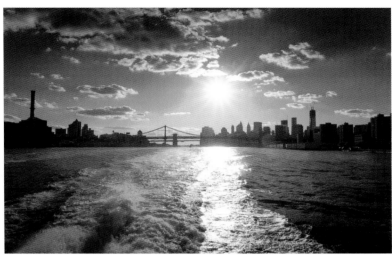

The Brooklyn and New York City skyline
taken from the East River Ferry
Sony SLT-A55V | ƒ/10 | 1/640 second | ISO 100

The Midtown Manhattan skyline
taken from Long Island City, Queens
Sony SLT-A77 | ƒ/14 | 1/250 second | ISO 50

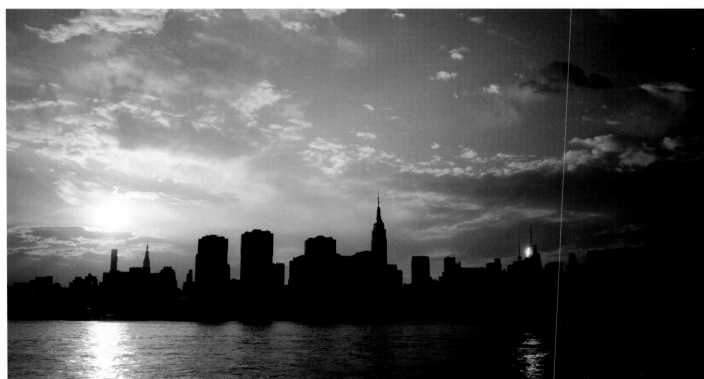

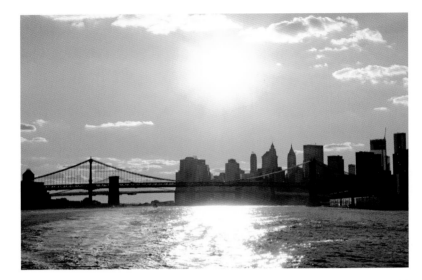

The Manhattan Bridge and New York City skyline taken from the East River Ferry
Sony SLT-A77 | *f*/14 | 1/250 second | ISO 50

Moments are vessels that contain: sparks, magic, effervescent happiness, lingering sadness, red-tinged anger, bittersweet joy; all waiting to explode if and when that point in time is visited again.

There are moments that exist somewhere between the excited beat of the heart and a welled-up tear in the eye.

They are the chills that run up the back of the neck and the small smile that can't be contained when their memory is nudged by a sound, sight, scent, touch.

It's the way the light was shining through the bridge as the boat pulled away under a sky blue with hope as the sun set and the lump in the throat subsided momentarily. It's the way the water looked as it rocked the boat gently like a lullaby as it drifted away from the sunlight that poured its light onto the surface of the water.

And it's the way everything seemed pointless in comparison to the way the clouds gathered over the city: hopeful tufts of smoke emanating from the sun's extinguishing fire.

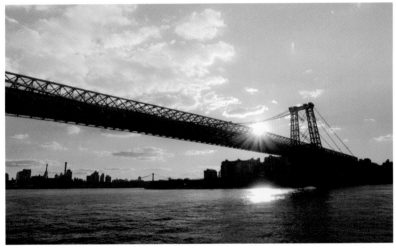

The Williamsburg Bridge and Lower East Side skyline taken from the East River Ferry
Sony SLT-A55V | *f*/10 | 1/200 second | ISO 50

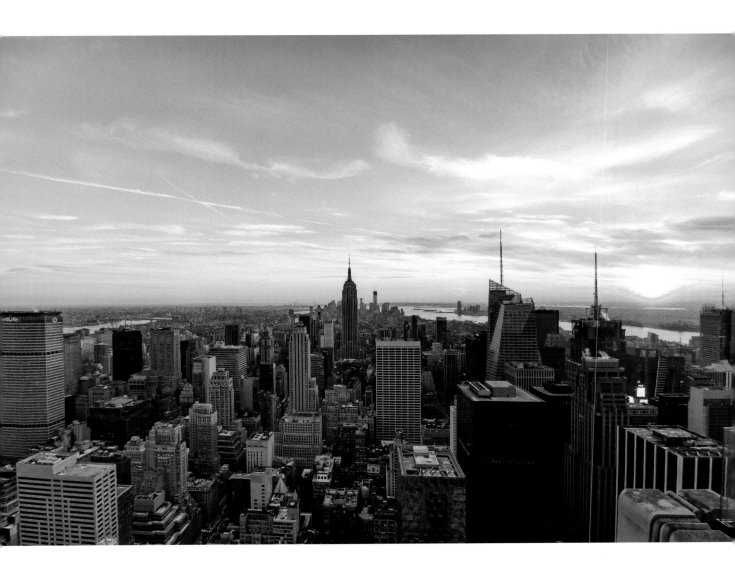

The Empire State Building and Midtown Manhattan
skyline taken from the top of Rockefeller Center
Sony SLT-A99V | f/5.6 | 1/80 second | ISO 200

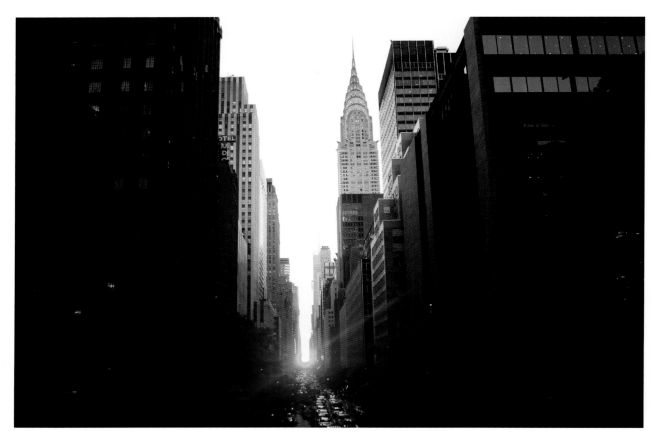

"

Manhattanhenge is a semiannual occurrence in which the setting sun aligns with the east–west streets of the main street grid in the borough of Manhattan in New York City. The term is derived from Stonehenge, at which the sun aligns with the stones on the solstices.

"

The Chrysler Building taken from Tudor City Place, Midtown Manhattan
Sony SLT-A55V | ƒ/4.5 | 1/100 second | ISO 200

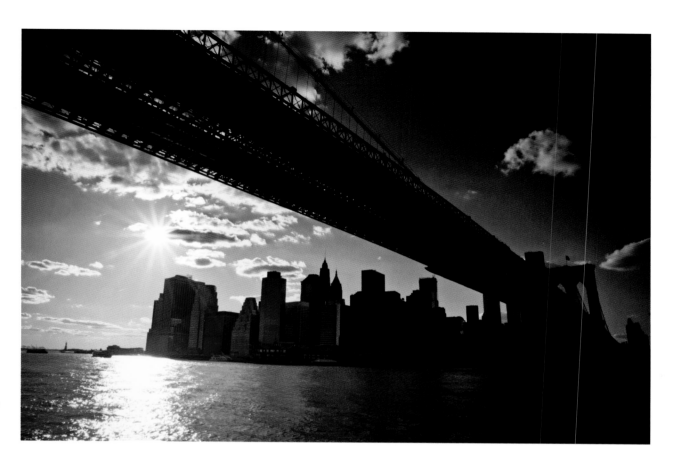

The Brooklyn Bridge and Lower Manhattan
skyline taken from the East River Ferry
Sony SLT-A77 | ƒ/10 | 1/250 second | ISO 50

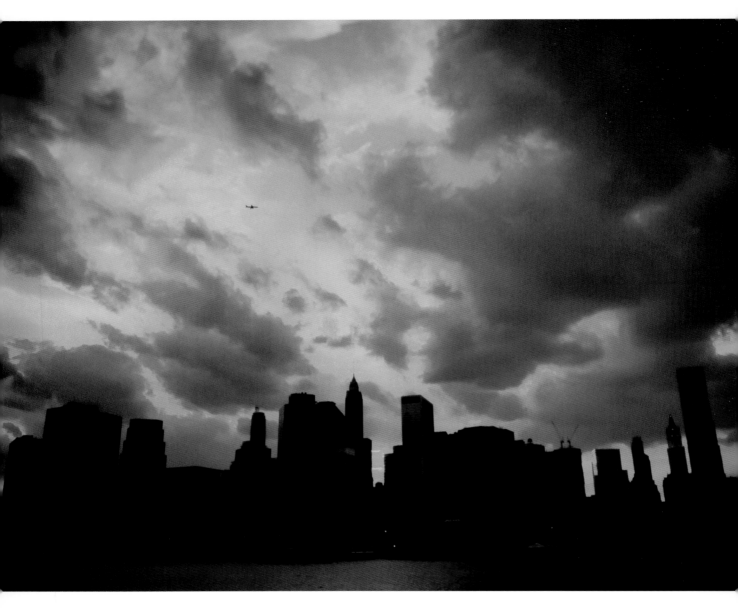

The Lower Manhattan skyline taken
from Brooklyn Bridge Park, Brooklyn
Sony SLT-A55V | f/9 | 1/200 second | ISO 100

> I used to refer to sunsets as sunfire.
>
> Those first sunsets burned through my retinas into the innermost recesses of my mind.
>
> Clouds poured over the smoldering sparks of orange like thick plumes of smoke and before the sun extinguished itself, it burned the brightest of any flame in existence.
>
> When the sun sets over New York City, it's as if a thousand flames dance across the sky, leaving embers scattered across the skyline in the wake of its burning: like a fevered dream scattering its remnants across the mind before the deepest of slumbers.
>
> I used to refer to sunsets as sunfire.
>
> I still do.

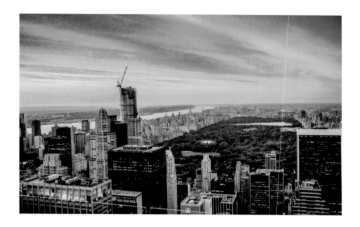

Central Park and the Midtown Manhattan skyline taken from the top of Rockefeller Center
Canon 5D Mk. III | ƒ/1.4 | 1/160 second | ISO 200

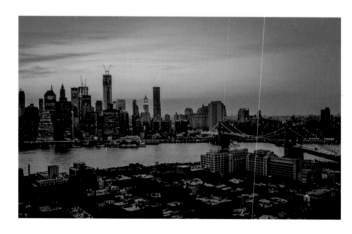

The Brooklyn Bridge and Lower Manhattan skyline, taken from an apartment in Brooklyn Heights, Brooklyn
Canon 5D Mk. III | ƒ/2.2 | 1/160 second | ISO 100

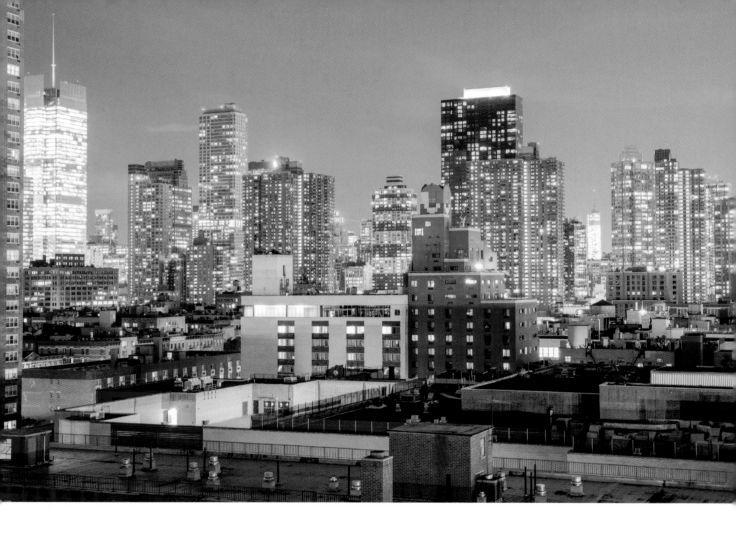

The Midtown Manhattan skyline taken from
a rooftop in Hell's Kitchen, Midtown Manhattan
Sony SLT-A99V | f/5.6 | 25 seconds | ISO 100

The Midtown Manhattan skyline taken from
a rooftop in Hell's Kitchen, Midtown Manhattan
Sony SLT-A99V | f/5 | 20 seconds | ISO 50

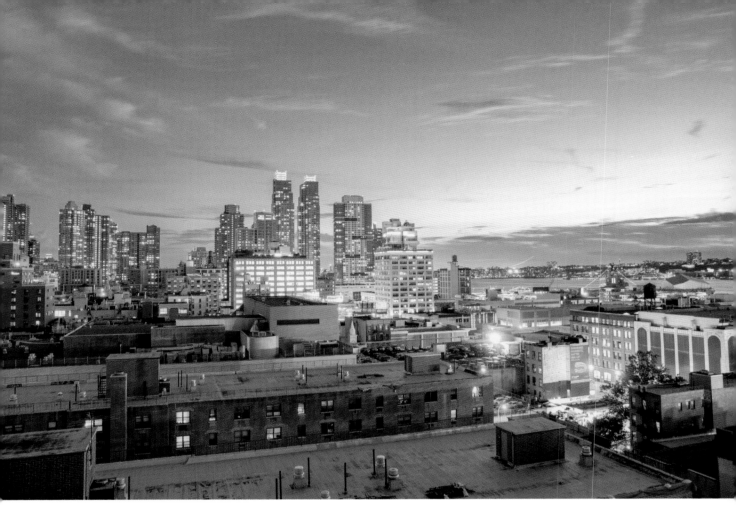

These photos were taken from a rooftop in Hell's Kitchen. The twin towers in the distance are a newer development called The Silver Towers. They were built in 2009 and have become a prominent part of the West Side skyline.

Hell's Kitchen is a neighborhood that has gone through a lot of changes over the last few decades. There has been a push to rebrand and rename the neighborhood in recent years with the names Clinton and Midtown West. However, the area is still colloquially known as Hell's Kitchen. The area encompasses the stretch from 34th Street up to 59th Street from 8th Avenue to the water.

Hell's Kitchen has a long history of violence. Already one of the most dangerous areas in America towards the end of the nineteenth century, the crime rate skyrocketed during Prohibition due to the many illegal warehouses located in the neighborhood. It experienced several surges in violence and crime in the twentieth century as well, due to an increase in gang activity and tension.

Today however, Hell's Kitchen is quite different. Despite its violent history, the neighborhood's proximity to restaurant row and the theater district have made it a hotspot for moderate and luxury real-estate developments.

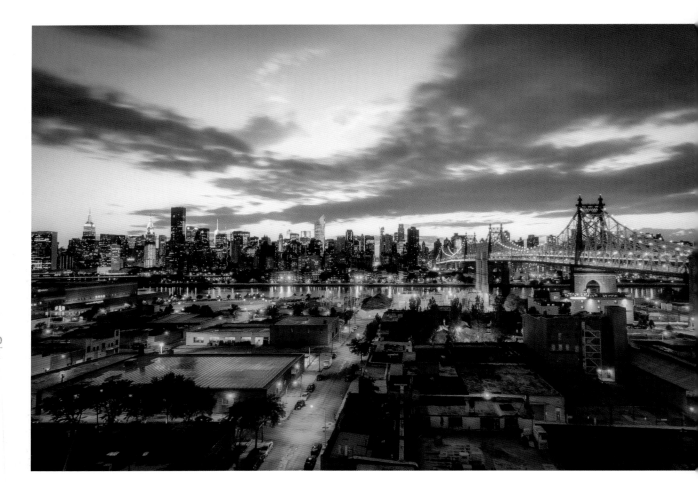

The Manhattan Bridge taken from
Brooklyn Bridge Park, Brooklyn
Sony SLT-A99V | ƒ/5.6 | 20 seconds | ISO 50

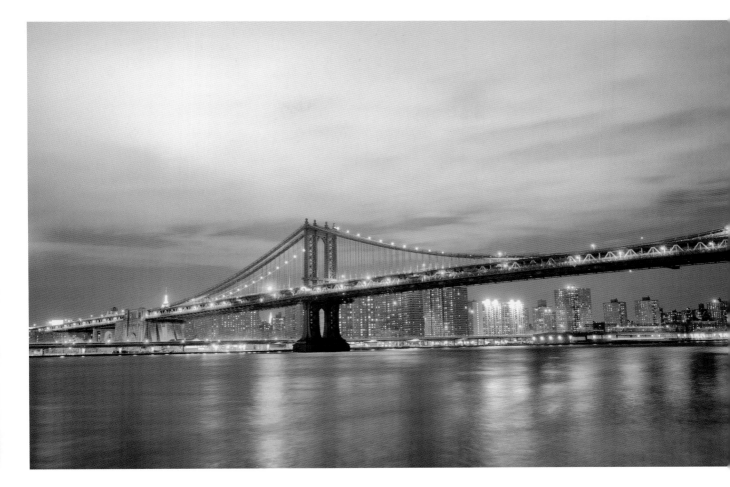

Winter can feel like an unforgiving season for outdoor photography. Daylight hours are short and the nights are often frigid and fraught with bitterly cold wind gusts. When it comes to photographing urban landscapes, however, winter can be ideal. Summer months bring haze and humidity, which can limit visibility and give cityscapes a muddy look. In contrast, winter months are usually free of haze, which allows for deeper clarity and increased visibility. When photographing dusk scenes, the colors that city lights cast are even more pronounced in the winter months due to the lack of haze. This particular photograph is a 30-second exposure that was taken on a gusty winter evening. Long exposures will usually result in a total smoothing of water surfaces. In this case, the water was so choppy that the surface of the river was still rendered rough.

The Midtown Manhattan skyline and the Queensboro Bridge taken from a rooftop in Long Island City, Queens
Sony SLT-A99V | f/6.3 | 30 seconds | ISO 50

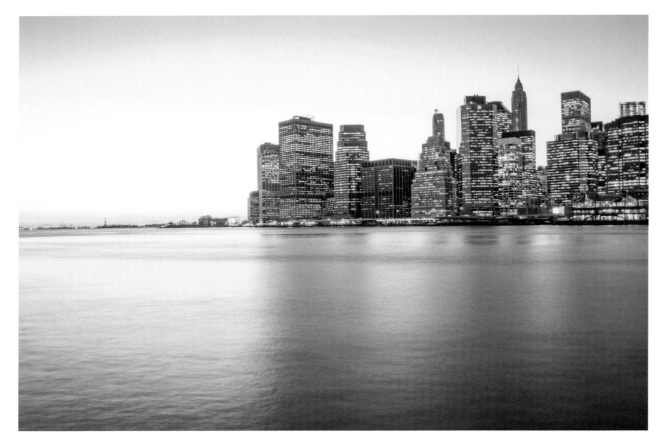

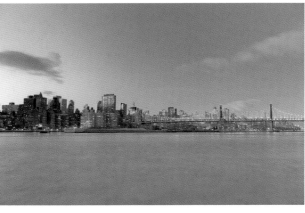

The Upper Manhattan skyline taken
from Roosevelt Island
Sony SLT-A99V | *f*/16 | 4 seconds | ISO 50

The Lower Manhattan skyline taken
from Brooklyn Bridge Park, Brooklyn
Sony SLT-A99V | *f*/8 | 20 seconds | ISO 50

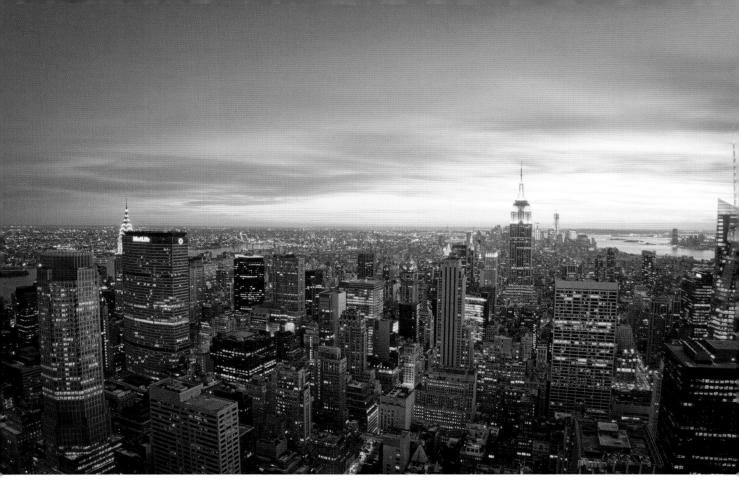

There is something really extraordinary about the shift between day and night in New York City.

It's gradual, yet at the same time abrupt in its magnitude.

The lights on the skyscrapers flicker on as the night sky pulls itself over the city while the sun is still dancing with the horizon.

It's this sort of in-between time that seems to suit a city full of people who feed off the frenetic energy and constant shifts that occur on a momentary basis.

After the sun sets, the city is a symphony of lights reaching their crescendo at the same time as the night comes down over the rooftops and skyscrapers below.

New York City rarely dwells in absolutes.

Only its landscape and structures seem to remain still.

The Midtown Manhattan skyline taken
from the top of Rockefeller Center
Sony SLT-A99V | ƒ/14 | 20 seconds | ISO 50

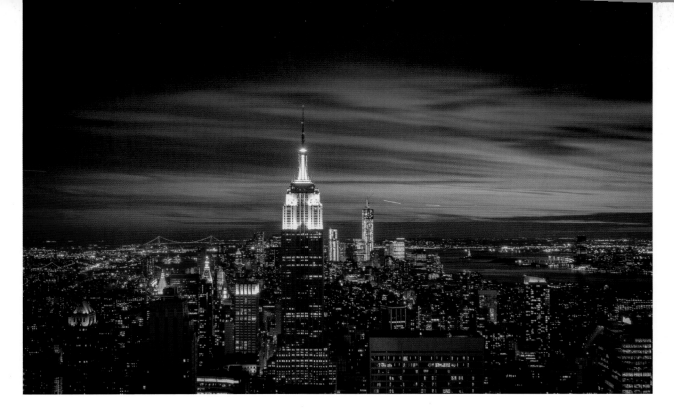

The hour right after the sun dips below the horizon is one of the most enchanting hours of the day. It's not quite day and not quite night but it's a blended mixture of the two. There is no better place to witness this transformation in New York City than 70 stories up in the air on the observation deck of Rockefeller Center (known colloquially as Top of the Rock). After feeling the elation that comes with watching the sun set over the city, all of the city's lights come into view twinkling little by little until they all seem to build up to the most intense crescendo of illuminated splendor.

This view is looking south towards Lower Manhattan past the Empire State Building, which I was able to capture by placing my camera on one of the ledges on the top of Rockefeller Center while tethered to a very, very still me with gloved hands in pockets barely breathing for fear of moving the camera/camera strap.

There is a special clarity that comes with this time of year. While this spot is a popular vantage point in the summer, there is also a lot less visibility due to the thick summer haze that hangs over the city in the warmer months. In the dead of winter though, it's crystal clear if you catch a clear day (another rarity!).

Locations of interest in this shot include: the Empire State Building, One World Trade Center (also known as the Freedom Tower or 1 WTC), the Statue of Liberty, Manhattan Bridge, the New York Life Building (one of the buildings with a gold top), and Metropolitan Life Insurance Company Tower.

The Empire State Building and Midtown Manhattan skyline taken from the top of Rockefeller Center
Sony SLT-A99V | ƒ/11 | 30 seconds | ISO 50

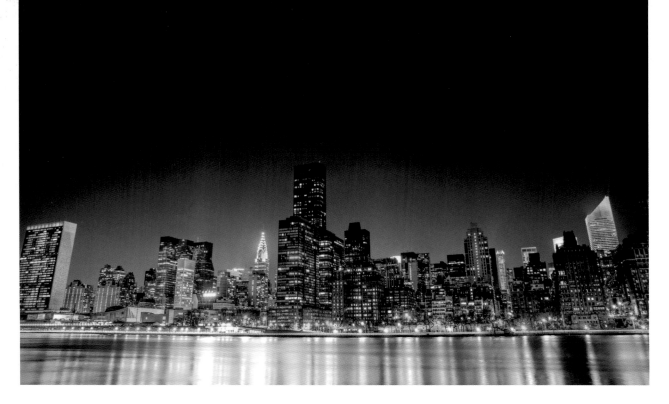

New York City has several prominent skyline views that are popular. One is in Lower Manhattan and usually includes the skyscrapers of the Financial District, along with one or more of the bridges that serve the lower part of Manhattan. Another series of skyline views can be found from the top of a few popular skyscrapers in Midtown Manhattan. Another series of views involves the Midtown Manhattan skyline as seen from different vantage points across (or in some cases directly from) the East River. This particular view is taken from one of the latter vantage points. It's a 30-second-long exposure taken on a gorgeously clear and cold night from Roosevelt Island.

Prominent skyscrapers in this view are the Chrysler Building and the United Nations Building (all the way to the left). The lights of other famous Midtown skyscrapers can also be seen even if those skyscrapers (looking at you, Empire State Building) are hidden in this view. The lights directly in front of the skyscrapers that line the East River belong to the FDR Drive, a major traffic route that lines New York City's east side.

The Midtown Manhattan skyline taken from Roosevelt Island
Sony SLT-A99V | f/5 | 30 seconds | ISO 50

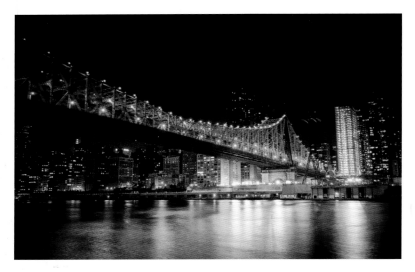

This is the Queensboro Bridge, which is known by a few other names depending on where you are from and how long you have lived in New York City. Despite growing up in Queens, I will always think of this bridge as the 59th Street Bridge because I think I belonged to one of the few families in Queens that for whatever reason associated the bridge more with 59th Street in Manhattan. It's also known as Queens Bridge, which is a shortened form of Queensboro Bridge. Its current official name is the Ed Koch Queensboro Bridge, named after the now-deceased former mayor of New York City who held office from the late 70s to the early 80s.

The Queensboro Bridge taken from Roosevelt Island
Sony SLT-A99V | f/6.3 | 30 seconds | ISO 50

The Queensboro Bridge taken from Roosevelt Island
Sony SLT-A99V | f/5 | 25 seconds | ISO 50

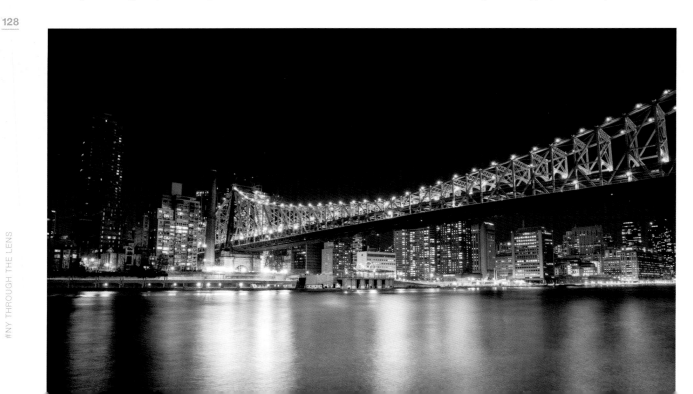

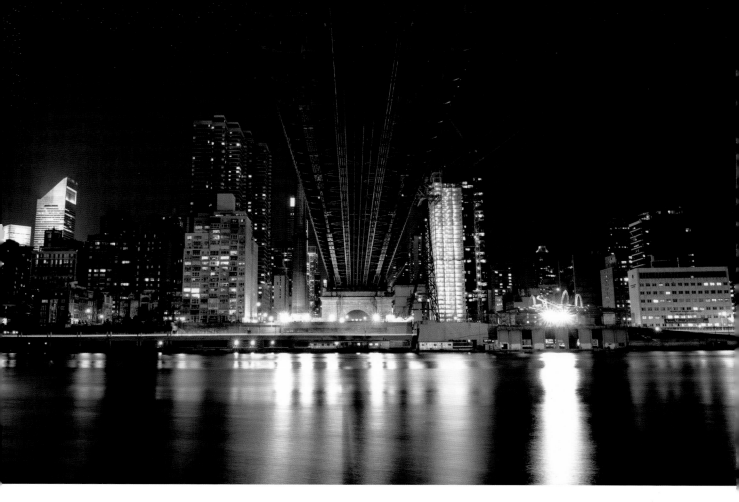

had a recurring dream when I was younger that puzzled me for years. It involved boarding a hovering bubble-shaped vehicle and ascending over the skyscrapers until I was soaring under the bridges and through the cavern-like spaces of the city. It was euphoric but also terrifying at the same time.

When I was older, I finally relayed the dream to someone and they laughed and asked if I had ever taken the Roosevelt Island Tram when I was young. The Roosevelt Island Tram is a commuter line that connects Midtown Manhattan to Roosevelt Island. It runs above the skyscrapers and rooftops of the eastern part of Midtown Manhattan and travels parallel to the Ed Koch Queensboro Bridge the way to an island that sits in the East River.

It prompted me to ask my mother if we had ever done such a thing and she said it was possible but she couldn't remember a specific time that we would have taken it (my mother, like me, is absolutely terrified of heights). It's possible that my family took the tram to Roosevelt Island at some point and the experience embedded itself deep into my imagination where it mixed with other flights of fancy (pun intended) of flying through a Gotham-like city like Batman.

The Queensboro Bridge taken from Roosevelt Island
Sony SLT-A99V | $f/7.1$ | 30 seconds | ISO 50

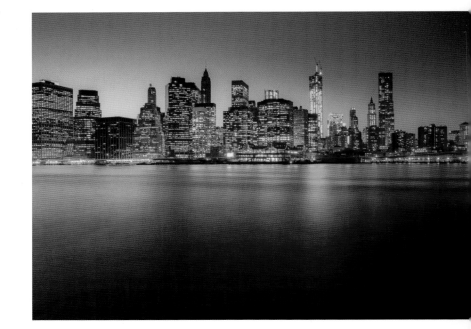

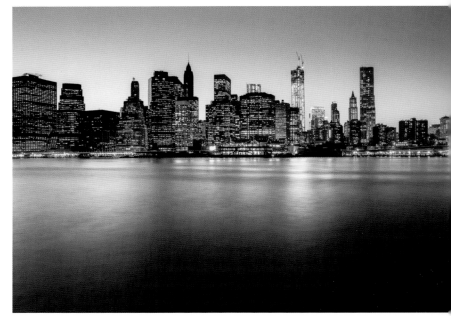

The Lower Manhattan skyline taken
from Brooklyn Bridge Park, Brooklyn
Sony SLT-A99V | f/14 | 30 seconds | ISO 50

The Lower Manhattan skyline taken
from Brooklyn Bridge Park, Brooklyn
Sony SLT-A99V | f/14 | 30 seconds | ISO 50

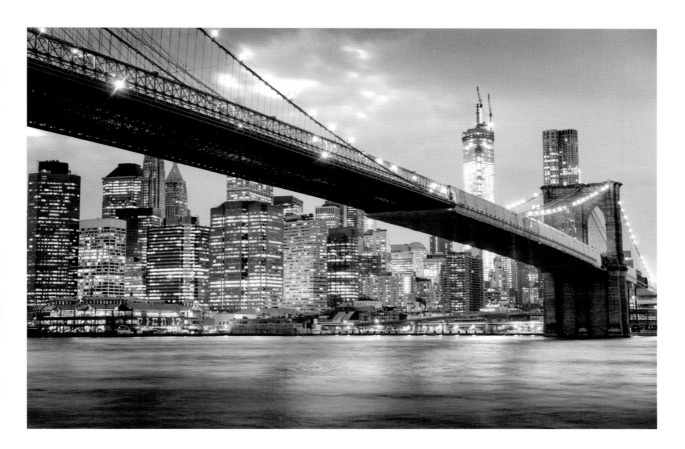

Brooklyn Bridge and the Lower Manhattan skyline
taken from Brooklyn Bridge Park, Brooklyn
Sony SLT-A99V | *f*/9 | 25 seconds | ISO 50

"

Skyscrapers come to life casting their light
over the water like nets; steely-eyed fishermen
with gleaming eyes.

And as the wind slow dances across the
surface of the water with the city lights,
the rest of the world seems to slip away.

"

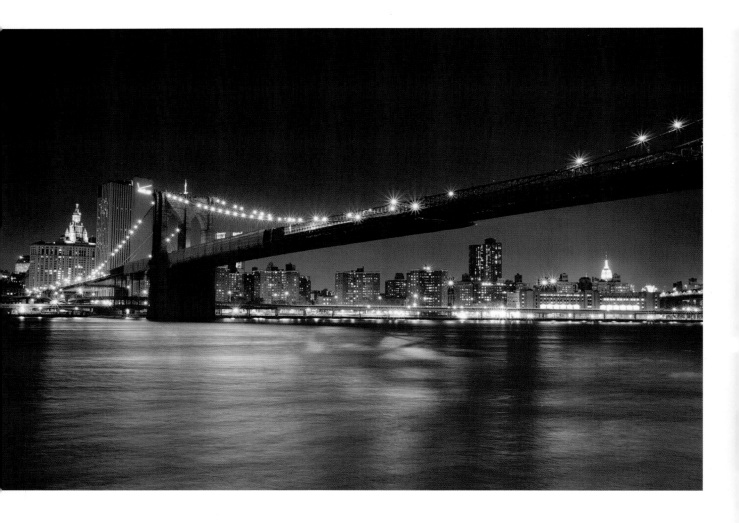

The Brooklyn Bridge taken from Brooklyn Bridge Park, Brooklyn
Sony NEX-7 | ƒ/7.1 | 13 seconds | ISO 100

The Brooklyn Bridge and Manhattan Bridge taken from Brooklyn Bridge Park, Brooklyn
Sony NEX-7 | ƒ/7.1 | 20 seconds | ISO 100

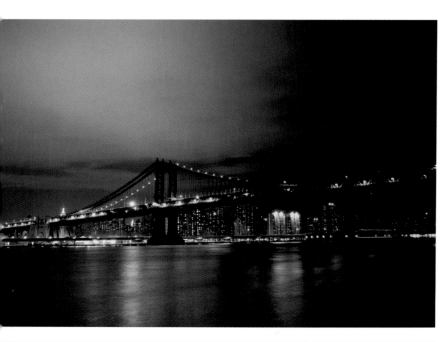

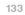

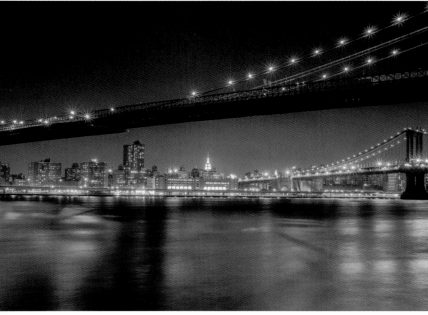

And the lights were
shining like stars:
rays poking themselves
out from the edge
of dreams
dancing with the
shadows below.
In the distance
a distant star shined
brighter and brighter
as the night sky
whispered bedtime
stories
in purple, hushed tones.
And the lights were
shining
like stars.

SEASONS

"

New York City rarely deals in absolutes and the weather follows suit. The city experiences all four seasons with wild abandon every year, and the seasons can be extreme in terms of both temperature and imagery. This volatility produces a prominent and transformative effect on the mood of the city.

"

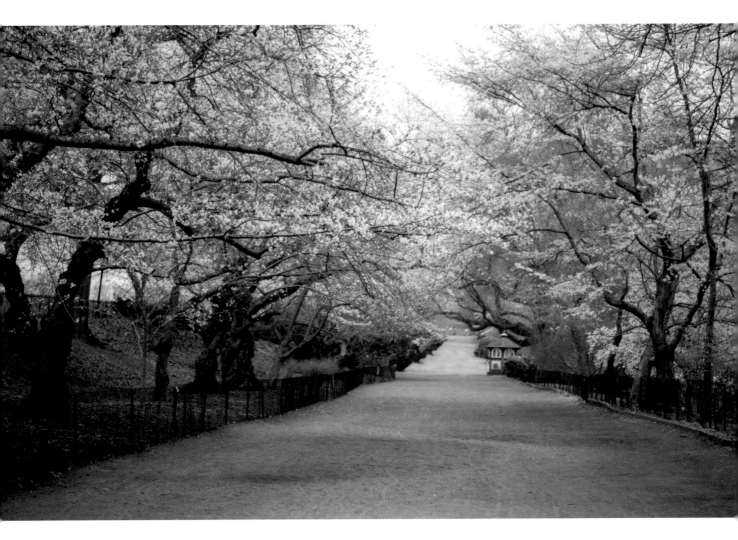

Visually, I am heavily influenced by the artistic visions of Impressionist and post-Impressionist painters like Édouard Leon Cortès and Claude Monet. When it comes to writing, my imagination is fueled by each season's distinct personality.

The changing seasons inspire me to explore my love of those two distinct artistic periods every year. I am always motivated by the emotions that a scene evokes, and seasonal landscapes resonate in a wide variety of ways.

The Bridle Path, Central Park, Manhattan
Sony SLT-A55V | f/1.8 | 1/450 second | ISO 200

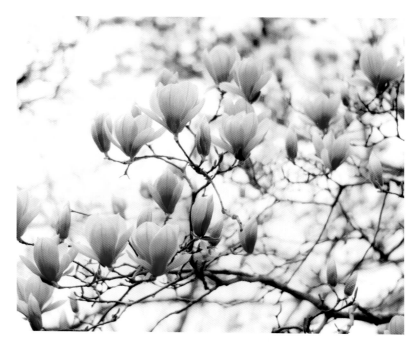

Central Park, Manhattan
Sony SLT-A55V | *f*/1.8 | 1/200 second | ISO 200

Where does the city's memory imprint itself? Is it imprinted on the concrete of sidewalks weathered by world-weary feet?

Is it imprinted in the foundations of the skyscrapers that scratch the surface of the sky connecting the sidewalks below to loftier aspirations?

Is it imprinted in the people whose lives unfold frenetically over the vast urban landscapes stretching across the city like veins and arteries?

Is it imprinted in the transportation systems that contract and expand like ligaments and tendons, flexing through the corporeal terrain?

Or is the city's memory imprinted on elements that only peripherally stake their claim on such a grandiose landscape?

In the petals of flowers, freshly opened and unfettered by permanence, the city effortlessly makes an impression like pressing a hand into soft flesh or falling slowly into a cloud.

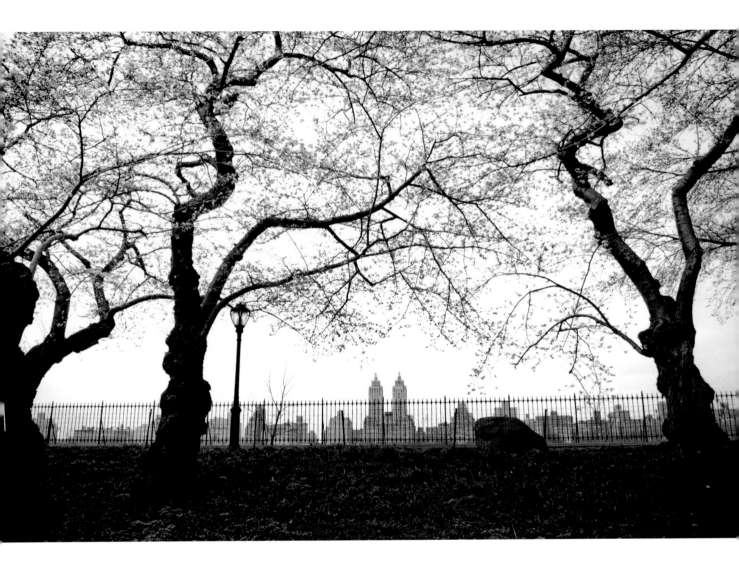

Brooklyn Botanic Garden, Brooklyn
Sony SLT-A55V | ƒ/2.2 | 1/160 second | ISO 200

The Jacqueline Kennedy Onassis Reservoir,
Central Park, Manhattan
Sony SLT-A99V | ƒ/3.5 | 1/100 second | ISO 200

Stuyvesant Square, Lower Manhattan
Sony SLT-A55V | ƒ/1.8 | 1/80 second | ISO 200

Brooklyn Botanic Garden, Brooklyn
Sony SLT-A55V | ƒ/2.2 | 1/400 second | ISO 200

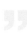 Brooklyn Botanic Garden, Brooklyn
Sony SLT-A55V | ƒ/2.2 | 1/40 second | ISO 200

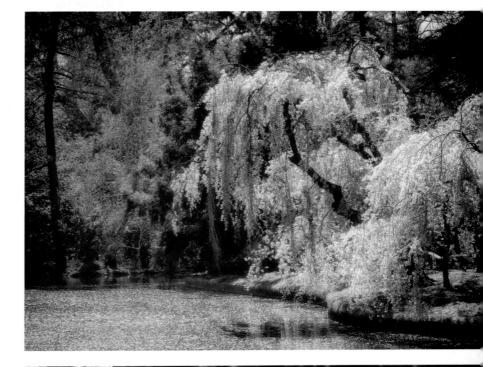

“

There are so many places to find serenity and nature in New York City. There are over 1,700 parks that span all five boroughs of New York City, many of which boast beautiful landscapes.

”

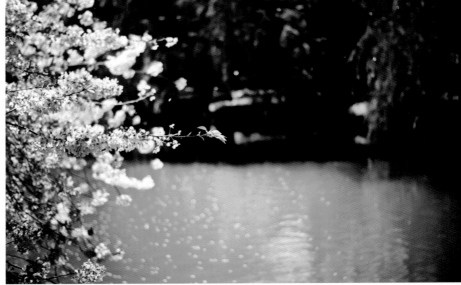

Winter's sun is distant, withdrawn and content to sleep behind clouds. Spring's sun, on the other hand, is ebullient, extroverted, and prone to magnificent displays of splendor. On afternoons, light from the sun pours over the earth, spilling itself onto every blade of grass, enchanting every fresh blossom with warmth and brilliance.

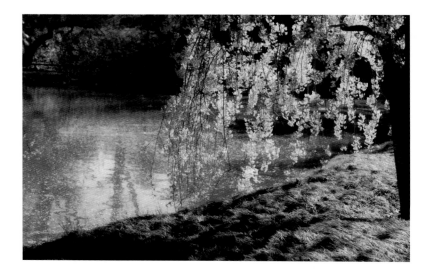

▶ Brooklyn Botanic Garden, Brooklyn
Sony SLT-A99V | f/5 | 1/80 second | ISO 100

▼ Central Park, Manhattan
Sony SLT-A99V | f/4 | 1/60 second | ISO 200

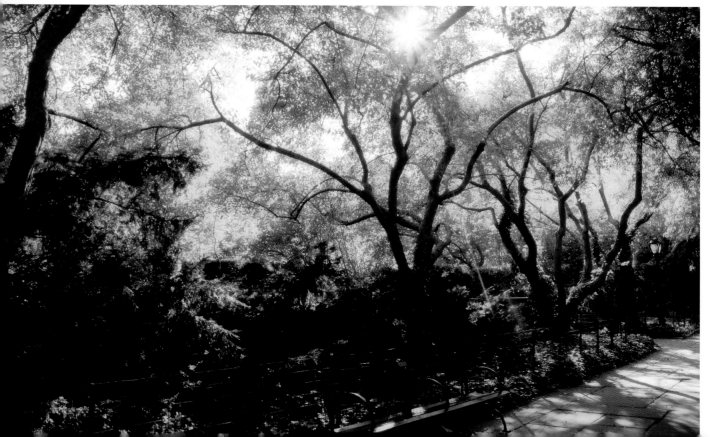

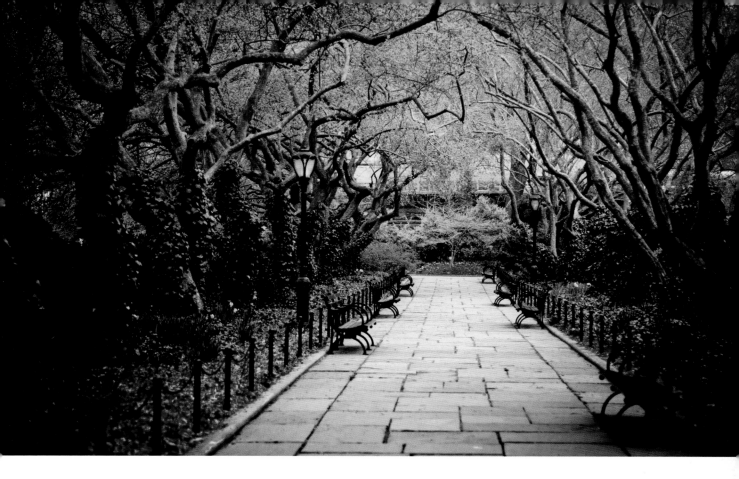

"

Weary after a long slumber, the urban forest stirs. Trees, in resplendent garments of ivy, stretch their graceful limbs toward each other as the dance of spring begins: a prelude to summer's grand symphonic poem.

"

Central Park, Manhattan
Sony SLT-A55V | ƒ/1.8 | 1/400 second | ISO 200

The East Village, Lower Manhattan
Sony SLT-A55V | ƒ/5.6 | 1/60 second | ISO 100

The East Village, Lower Manhattan
Panasonic FZ35 | ƒ/2.8 | 1/80 second | ISO 100

Kissed by the sun, the day lingers long into the night.

Earth devours every last bit of light as trees sway with their graceful branches adorned by summer's heavy garlands.

And the glow of daylight's promises basks in its transient longevity.

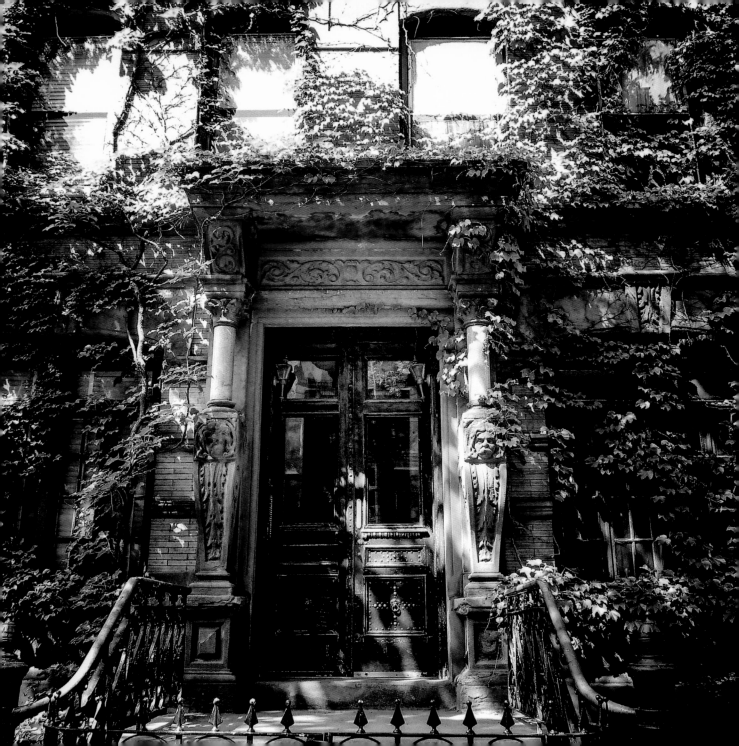

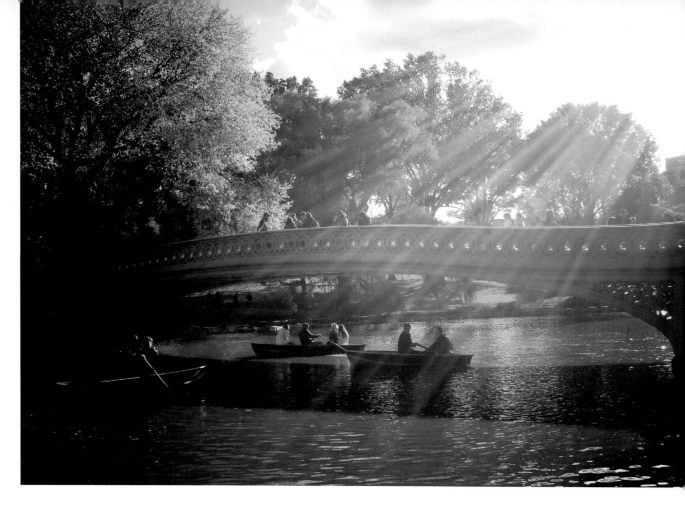

"

There are moments that remain etched
into time: moments that aren't easily
forgotten no matter how much time
passes in the yawning gaps between
memory and dreaming.

"

Central Park, Manhattan
Samsung ES15 | ƒ/8.4 | 1/250 second | ISO 400

Central Park, Manhattan
Sony SLT-A55V | ƒ/17 | 1/125 second | ISO 100

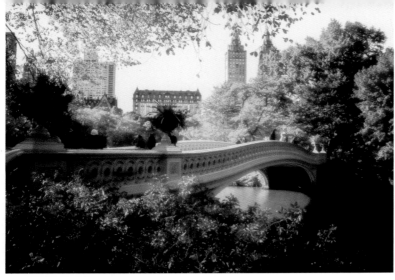

Central Park, Manhattan
Samsung ES15 | ƒ/8.4 | 1/250 second | ISO 400

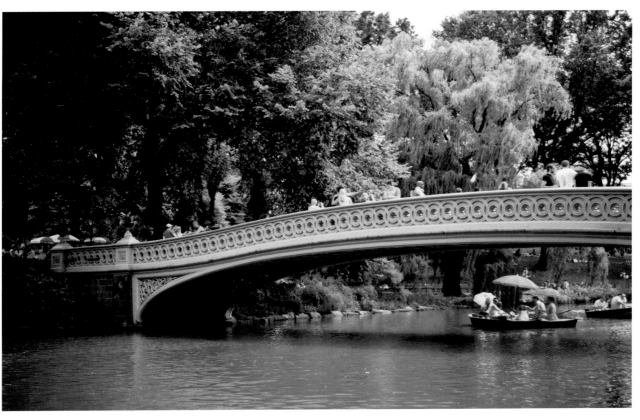

▶ Fort Tryon Park, Upper Manhattan
Sony SLT-A99V │ ƒ/3.2 │ 1/60 second │ ISO 250

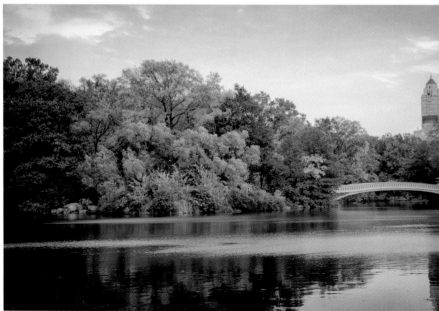

▶ Central Park, Manhattan
Sony SLT-A99V │ ƒ/4.5 │ 1/60 second │ ISO 250

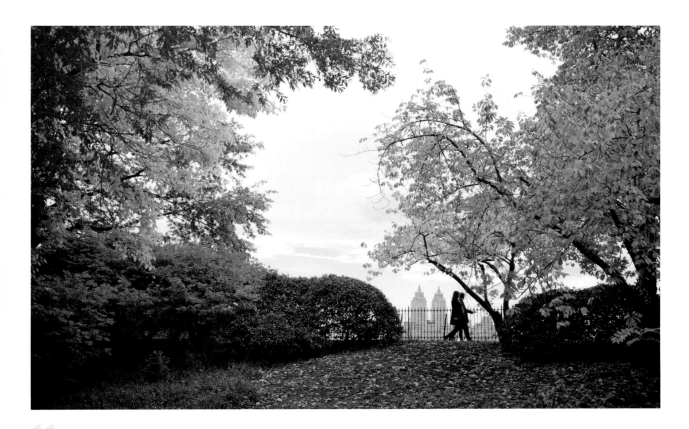

Autumn is the start of something new. It's the promise of briskness followed by warmth. It's an inviting whisper that lingers in the air and brushes past the skin with its transient presence.

We inhale the earth's transition deeply into our lungs and exhale hopeful utterances on the condensation of our warm breaths.

The Jacqueline Onassis Reservoir,
Central Park, Manhattan
Sony SLT-A99V | f/4.5 | 1/100 second | ISO 100

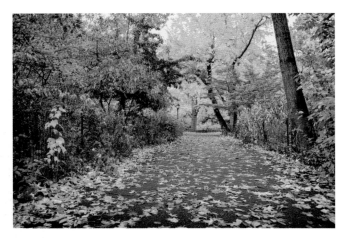

Central Park, Manhattan
Sony SLT-A99V | ƒ/5.6 | 1/30 second | ISO 400

Central Park, Manhattan
Sony SLT-A99V | ƒ/3.5 | 1/40 second | ISO 1250

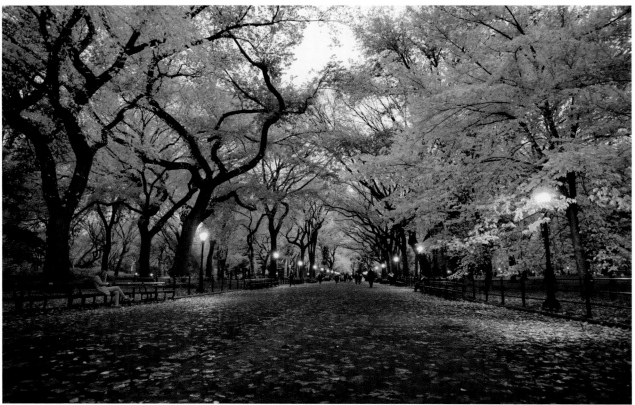

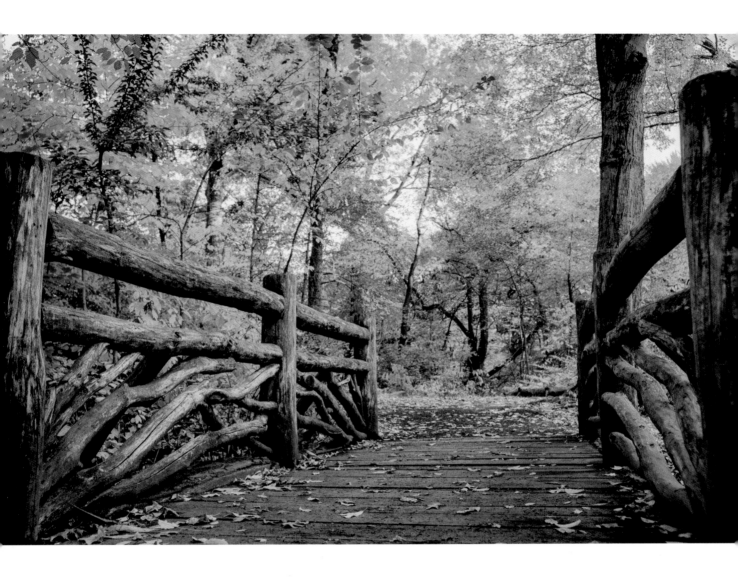

Central Park, Manhattan
Sony SLT-A99V | *f*/5 | 1/50 second | ISO 400

adore a moody autumn afternoon, especially after a good rain. The smell of the leaves on the wet ground, the faint scent of firewood that lingers in the air, the slip of the leaves underfoot, the sound of tiny waterfalls in The Ramble, the symphony of autumn colors: it's overwhelming in the all the best ways.

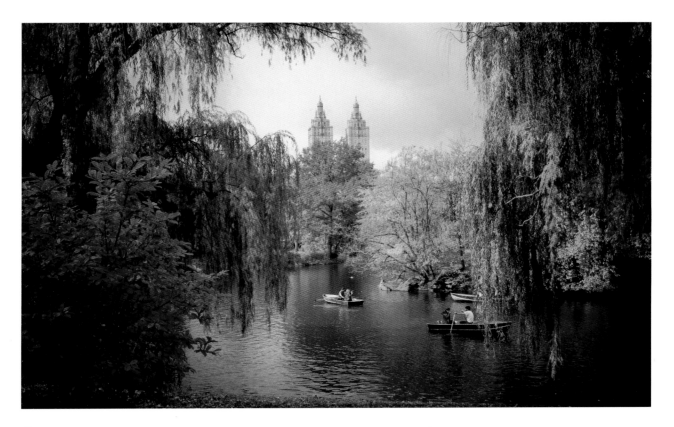

The East Village, Lower Manhattan
Samsung ES15 | ƒ/3.2 | 1/350 second | ISO 200

Central Park, Manhattan
Sony SLT-A55V | ƒ/4 | 1/1600 second | ISO 200

There are days in Central Park during the autumn when the weather is deliciously ominous. These are the sorts of days when gray clouds do their best to compete with the sunlight for the spotlight. I love the quality of this sort of contrasting light. At moments when the sun does manage briefly to peek through the gray blanket of clouds, the foliage seems to reel in the rays of scattered sunlight.

Above is a vista that seems to come alive in the autumn and winter due in part to Central Park's beautiful willow trees. There is

a quality to the placement of the branches that is reminiscent of theatrical stage curtains in a persistent state of dramatically opening to reveal the landscapes that are just beyond their grasp, as if they are revealing a show that comes alive in the final two acts of a performance that spans a year.

In the autumn, these branches frame the sprawling autumn landscape that surrounds the lake, and in the winter when the lake is covered in snow, the same branches hold multitudes of icy tears framing the towers of San Remo perfectly.

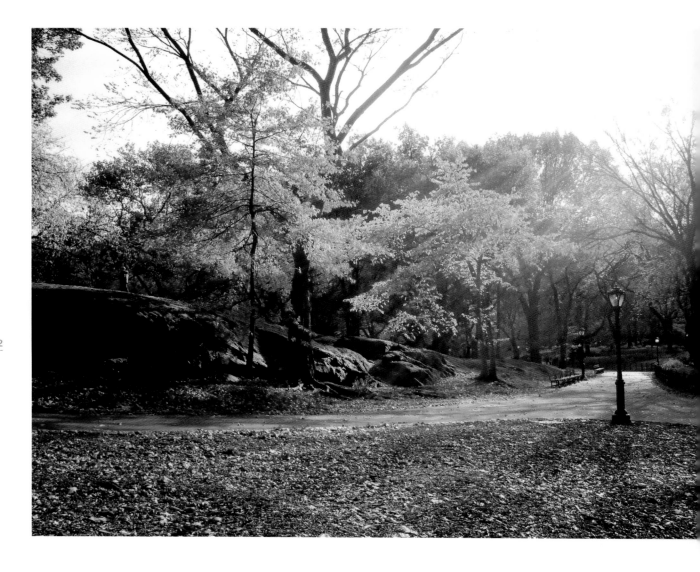

It's in the way the sunlight streams through the last vestiges of autumn: as golden as the leaves that hold onto their branches.

It's in the way the earth bares itself under this fanfare: as vulnerable as new lovers' heartbeats buried under layers of clothing.

▲ Central Park, Manhattan
Samsung ES15 | ƒ/8.4 | 1/250 second | ISO 200

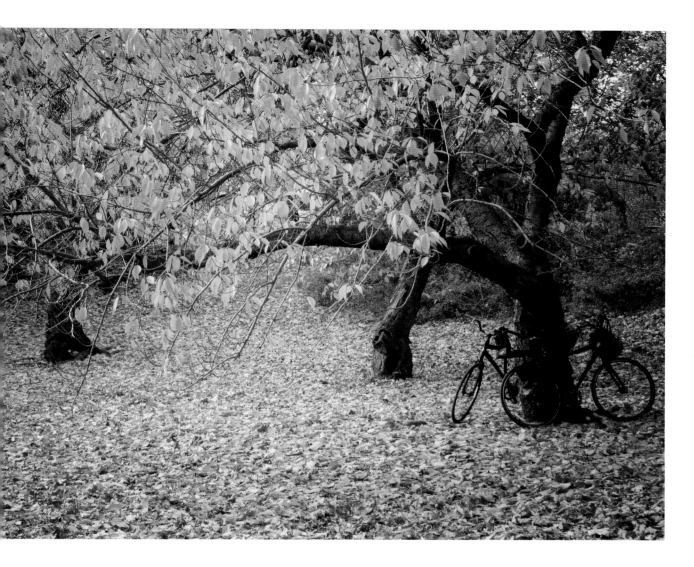

Winter's prelude starts slowly: a distant refrain that works its way through the earth chilled in anticipation.

That chill in the air wrapping itself around trees like an overflowing scarf, trees displaying decorated limbs in golden shades of serenity.

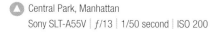 Central Park, Manhattan
Sony SLT-A55V | f/13 | 1/50 second | ISO 200

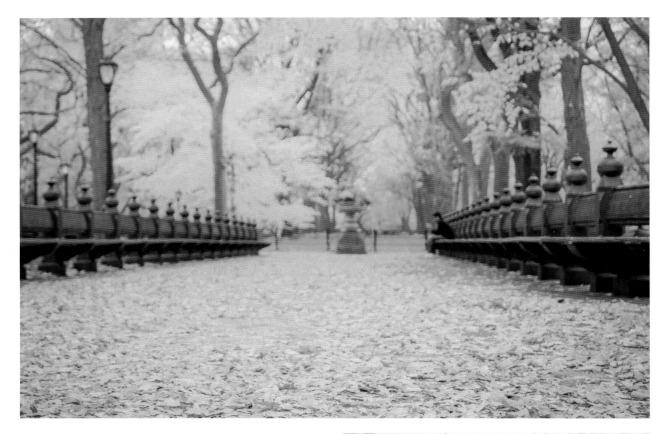

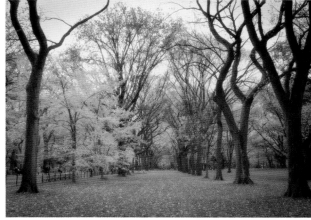

⬤ Central Park, Manhattan
Sony SLT-A55V │ *f*/5 │ 1/200 second │ ISO 200

▶ Central Park, Manhattan
Sony SLT-A55V │ *f*/5 │ 1/160 second │ ISO 400

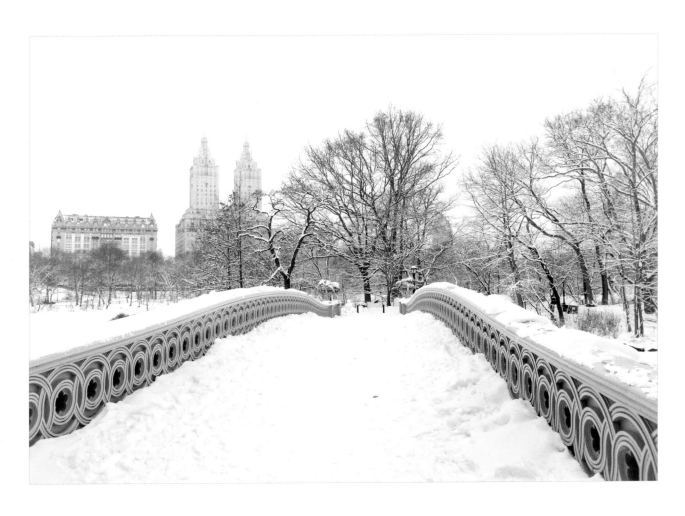

Central Park, Manhattan
Panasonic FZ35 | f/5.6 | 1/200 second | ISO 200

Central Park, Manhattan
Sony SLT-A55V | f/4 | 1/200 second | ISO 200

Bow Bridge is one of Central Park's most iconic structures. It was built between 1859 and 1862 and is shaped like an archer's bow. This particular image was taken during a snowstorm in Central Park. Bow Bridge sits covered by a beautiful layer of freshly fallen snow as the buildings that line Central Park West sit in the distance just past the snow-laden trees.

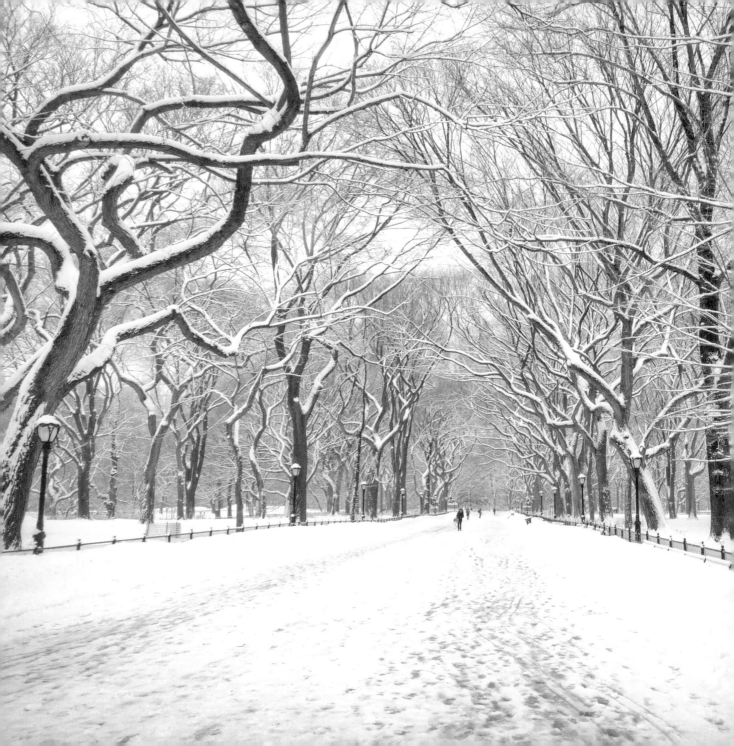

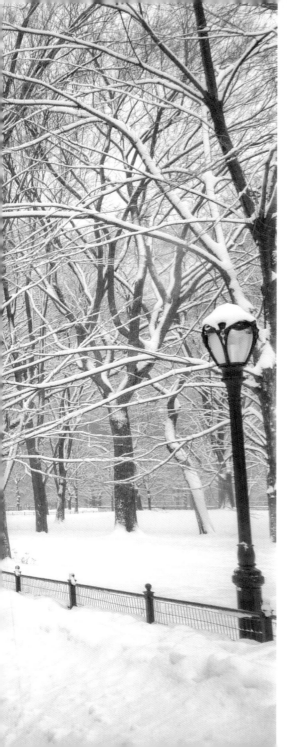

I love heavy snowfall and I found myself braving the super high wind gusts to wander around a mostly empty Central Park during one particularly rambunctious blizzard. I don't really recommend it and, thinking back, it was a bit risky considering that the wind gusts were around 55 mph and higher. Gusts and trees don't make for the safest of combinations. However, I have never seen Central Park in such a serene state.

The only people who were in the park that day were a few people who lived in the surrounding neighborhoods, brave tourists, and intrepid photographers with giddy expressions on their faces. I could probably count on both hands the number of people I encountered and I ended up covering most of the park on foot that day.

This part of Central Park is known as the Poet's Walk or Literary Walk. The reason that this part of the park is known as Poet's Walk and/or Literary Walk is because at the very end of this section several statues of famous writers line the path. It's at the southern end of a section called the Mall.

The Mall is the only straight path in Central Park and the trees that line it are its crowning and most distinctive feature. They are American elm trees and are the largest and last remaining stands in all of North America.

The Poet's Walk is one of my favorite spots in the autumn and winter because the trees look their most graceful and beautiful during these seasons. The leaves turn a beautiful golden yellow in the autumn, and the elegant branches seem to reach out to each other when covered by freshly fallen snow in the winter.

Central Park, Manhattan
Sony SLT-A55V | ƒ/5 | 1/100 second | ISO 200

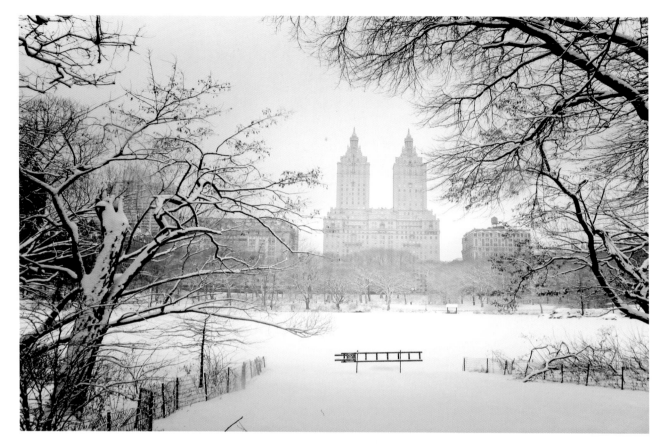

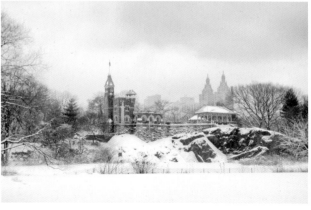

▲ Central Park, Manhattan
Sony SLT-A55V │ *f*/7 │ 1/160 second │ ISO 200

◄ Belvedere Castle, Central Park, Manhattan
Sony SLT-A55V │ *f*/5 │ 1/100 second │ ISO 200

◄ Central Park, Manhattan
Sony SLT-A55V │ *f*/5 │ 1/160 second │ ISO 200

► Central Park, Manhattan
Sony SLT-A55V │ *f*/7 │ 1/160 second │ ISO 200

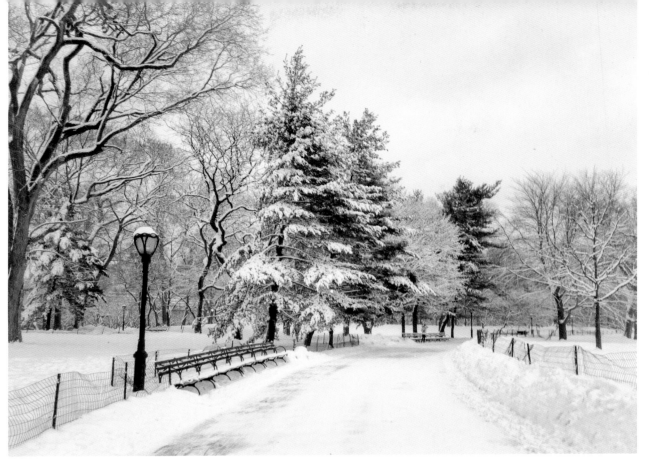

These photos were taken during a major snowstorm in New York City. The rustic wooden fence in the bottom photo runs through a four-acre section of Central Park known as the Shakespeare Garden, located in the west part of the park near 79th Street. On the 300th anniversary of William Shakespeare's death in 1916, this area was dedicated to Shakespeare and also renamed in his honor. The plants and flowers that are found in this area all featured in the works of the playwright or in his garden in Stratford-upon-Avon. There is even a white mulberry tree on this plot of land that is said to have grown from a graft of a tree planted by Shakespeare himself in the 1600s.

While the paths that winds through Central Park's Shakespeare Garden is gorgeous in the warmer months of the year, it's absolutely stunning when snow has freshly fallen.

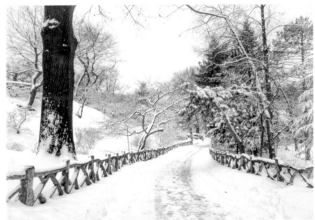

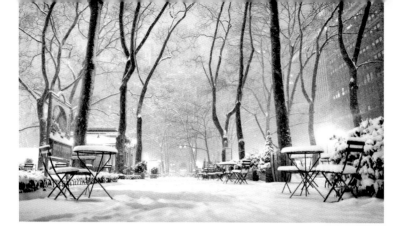

Bryant Park, Midtown Manhattan
Sony SLT-A99V | ƒ/4 | 1/80 second | ISO 4000

Central Park, Manhattan
Sony SLT-A55V | ƒ/5 | 1/40 second | ISO 400

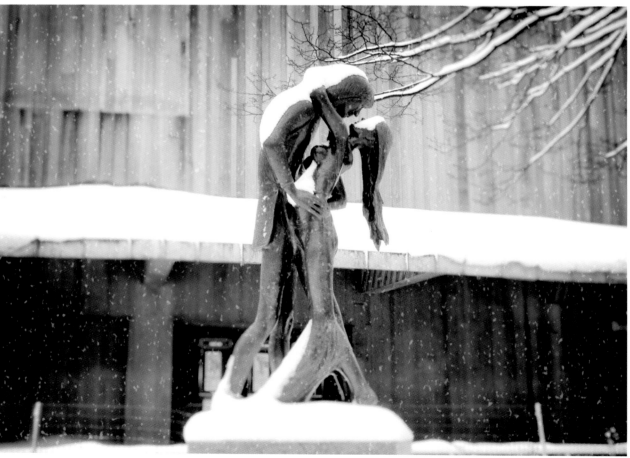

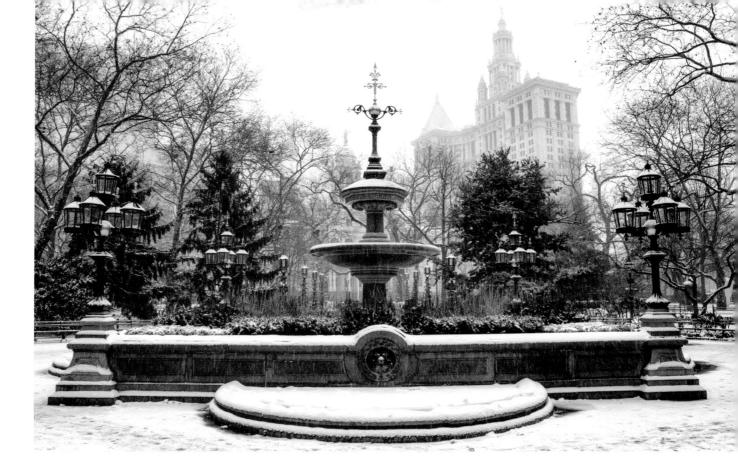

All heartbeats, all footsteps, all meandering thoughts and evocations are wrapped in a heavy blanket of snow. Trees cease reaching for the sky, weighed down by the weight of the sky's tears of joy and there is scarcely a breath to be heard.

Winter muffles the earth silencing its yearnings, and all at once there is peace.

City Hall Park, Lower Manhattan
Sony NEX-6 | ƒ/5 | 1/60 second | ISO 100

"

New York City evolves at a rapid pace. Change occurs faster in some areas than in others. Lower Manhattan is one place that has changed the most over the last decade. Development happens fast and the current trends are for tall buildings constructed mostly of glass, housing chain stores, and luxury boutiques. In neighborhoods that were once home to artists and rebels, long-time residents have found these changes hard to swallow. They're often at risk of being priced out of neighborhoods they have called home for decades.

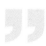

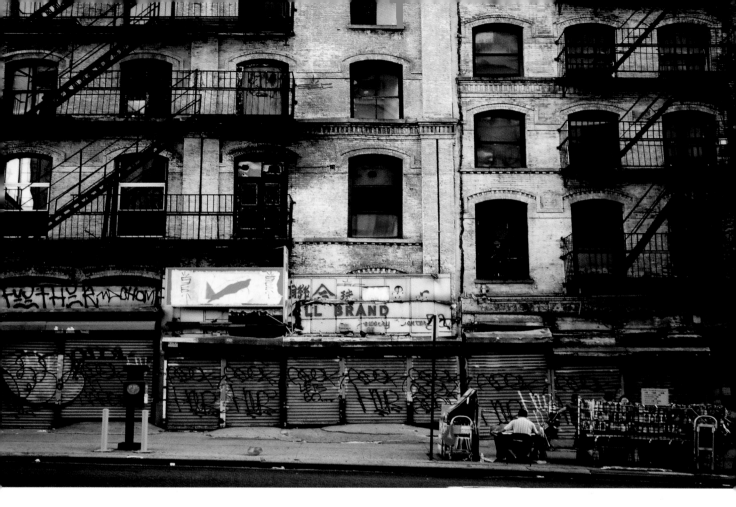

Despite these changes, there are still parts of Lower Manhattan that recall earlier decades. During the 1970s, Manhattan suffered economically and much of Lower Manhattan was transformed into a danger zone, full of rampant crime and abandoned lots and buildings. Having grown up in New York City in the 1980s and early 1990s, I have vivid memories of riding graffiti-covered trains from Queens to Manhattan. I was taught to watch my back at all times, since everyone seemed to know someone who had been mugged. Things were different in the days prior to the initiatives made by Mayor Koch and Mayor Guiliani to "clean up" the city. Discourse is still rampant regarding how they handled it.

When I first came across this section of Canal Street my heart almost leapt out of my chest. Here I was, staring at a spot in Chinatown that seemed as if it had been frozen in the New York City of the 1980s. Thankfully, I had my camera. It's hard to put into words how powerful this scene is for me personally. It's a bit like staring at something that once existed in a distant life.

A city may change rapidly, discarding pieces of itself along the way, but it is the people, who carry its broken pieces in their hearts, that imbue the city with its memory.

Chinatown, Lower Manhattan
Sony SLT | A55V | ƒ/4.5 | 1/200 second | ISO 200

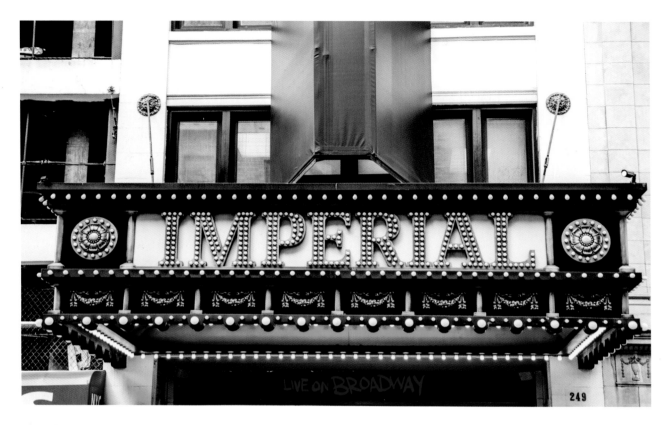

The Theater District is an area of Midtown Manhattan where the majority of Broadway theaters are located. It runs from around West 40th Street all the way up to West 54th Street. Many of the theaters still retain their original architecture and signs, which makes it a special place to enjoy the history of entertainment in New York City.

The Imperial Theater (above) opened on New York City's Broadway in the 1920s. It was constructed to specifically foster musical performances on Broadway. Among the famed twentieth-century composers whose works found a home here are: Cole Porter, Richard Rodgers, Lorenz Hart, Irving Berlin, Harold Rome, Frank Loesser, Lionel Bart, Bob Merrill, Stephen Sondheim, Jule Styne, E. Y. Harburg, Harold Arlen, and George and Ira Gershwin.

Many of the Broadway theaters in New York City were built in the late nineteenth century and early twentieth century. You can see the period architecture in the image opposite, top right; a detail from one of the many theaters in Midtown Manhattan.

The Majestic Theater (right) was built in the 1920s. The Majestic is the largest theater on Broadway and has been home to *The Phantom of the Opera* since its NYC opening in the 1980s. The theater was purchased by the Shubert brothers during the Great Depression and is an official New York City landmark.

Broadway is teeming with gorgeous architecture. The theater windows in the detail opposite, bottom right, have ornate frames and are the portals into a Broadway costume dressing room.

▲ Imperial Theater, Broadway, Midtown Manhattan
Sony SLT-A99V | f/3.5 | 1/25 second | ISO 50

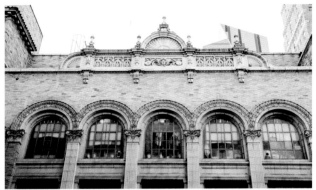

Broadway, Midtown Manhattan
Sony SLT-A99V | ƒ/3.5 | 1/60 second | ISO 50

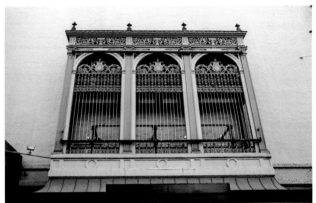

Broadway, Midtown Manhattan
Sony SLT-A99V | ƒ/3.5 | 1/60 second | ISO 50

Majestic Theater, Broadway, Midtown Manhattan
Sony SLT-A99V | ƒ/2.8 | 1/125 second | ISO 50

It's fascinating to consider the various ways in which we take our versions of where we live for granted, as if the places we inhabit sprouted forth perfectly sculpted into their current incarnations.

Perhaps this is why if you live in any one place for an extended amount of time, you become deeply attached to a definitive notion of time and place that doesn't specifically exist.

And when you come across places in your current environment that run counter to that notion, it's enough to take your breath away momentarily.

168

 Lower West Side, Manhattan
Sony SLT-A99V | f/1.5 | 1/60 second | ISO 200

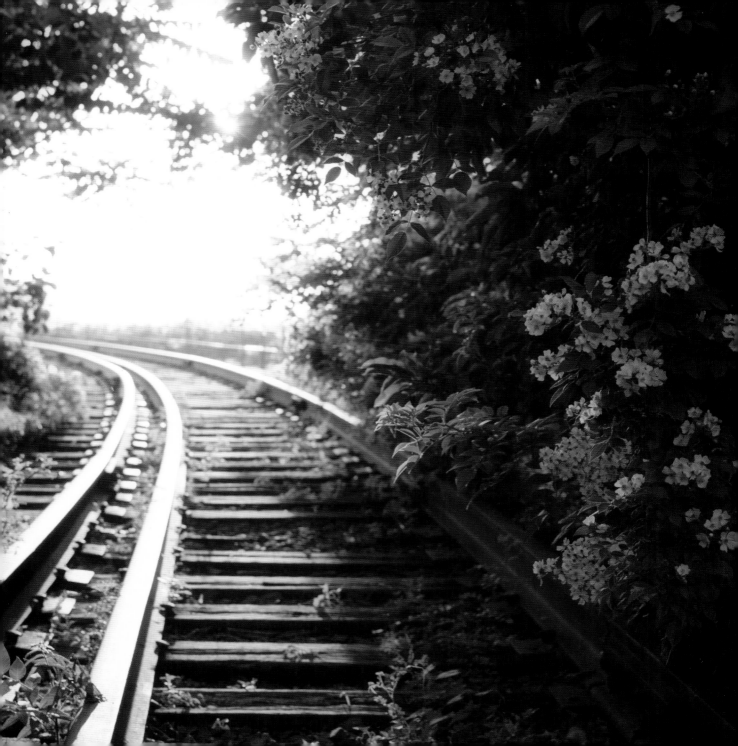

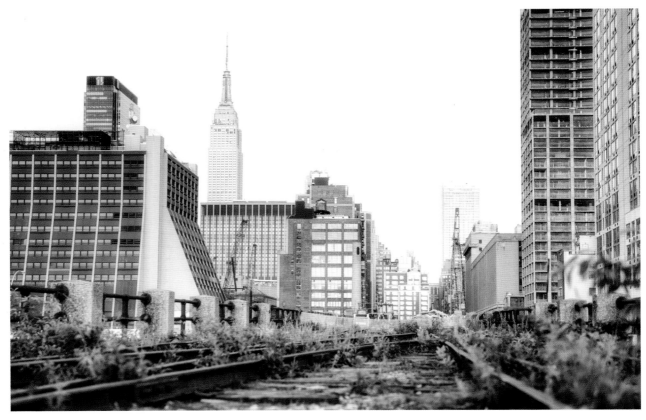

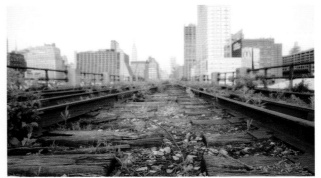

Lower West Side, Manhattan
Sony SLT-A99V | ƒ/3.2 | 1/60 second | ISO 400

Lower West Side, Manhattan
Sony SLT-A99V | ƒ/2.8 | 1/60 second | ISO 125

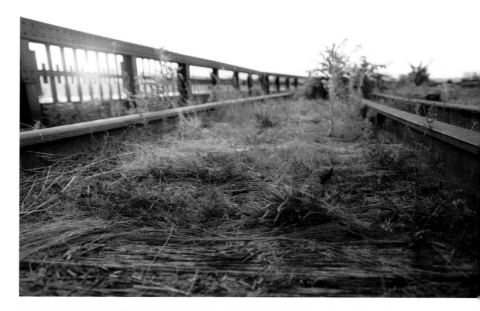

In the 1930s, freight trains ran along these re-purposed tracks delivering supplies and service to the buildings along the High Line. In some of the newer sections, the closeness of the buildings that line the tracks is made all the more extreme by the wildflowers that have sprouted up along what remains of the train tracks. The shaded areas are brimming with colorful flowers and plant life that has claimed its home here, breathing life into this space that was once dominated by industry.

The final section of the High Line is known as High Line at the Rail Yards. I received a guided tour of the unfinished part of this former railroad. It couldn't have been a more beautiful evening to walk alongside the historic railroad tracks, which were surrounded by fresh spring vegetation.

As the sun dipped lower in the sky, it felt like I was transported to an entirely different time period in the past or in an alternate future where nature has started to reclaim the city. It's rare to see views like this in New York City, especially in Manhattan, where development rushes along at a rapid pace.

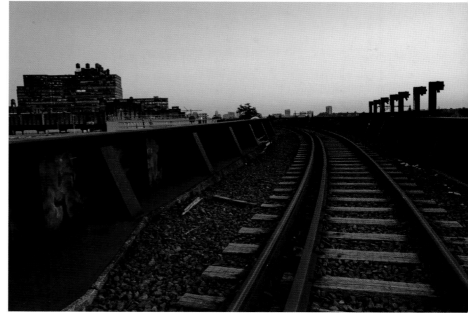

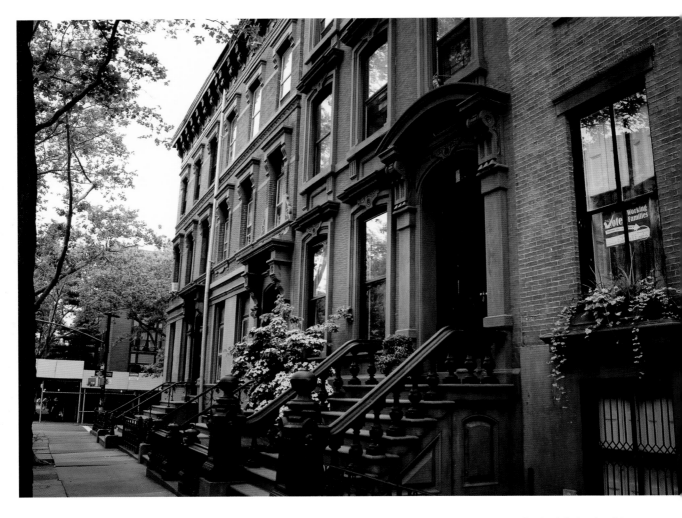

had severe brownstone envy when I was younger. Growing up in Queens I visited Brooklyn frequently, and the brownstones that are numerous in that borough tugged at my heart. Their ornate doorways were flanked by extravagant stairways, and every window seemed to be a frame encapsulating an enticing painting.

There was nothing that came close to these beautiful works of architecture where I grew up in Queens. Watching the Cosby Show fueled my envy of course. I had no idea at the time that the exterior shots of the Cosbys' brownstone were shot in Greenwich Village and not in Brooklyn Heights, where the Cosbys' fictional residence was located (why they did this is beyond me since Brooklyn Heights is home to some of the most beautiful brownstones). All I knew was that these masterpieces of architecture just seemed more "New York City" than any of the buildings I grew up surrounded by.

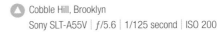 Cobble Hill, Brooklyn
Sony SLT-A55V | *f*/5.6 | 1/125 second | ISO 200

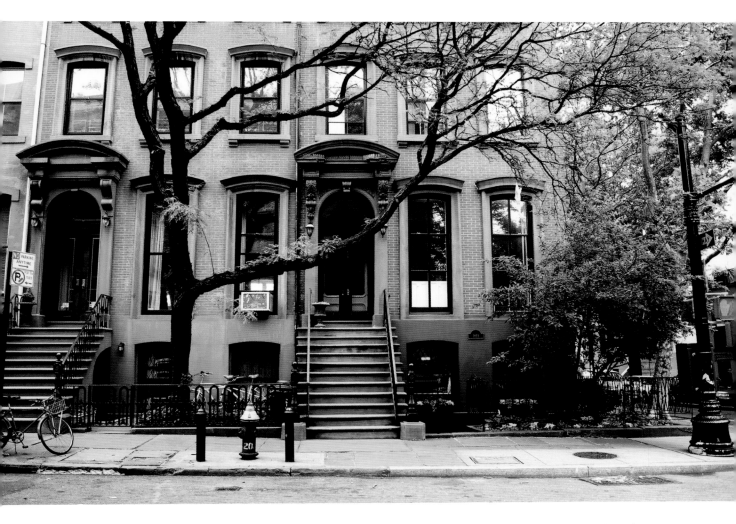

These deep red-brick brownstones can be found in neighborhoods like Cobble Hill, located in Brooklyn. Cobble Hill (or Ponkiesbergh as it was first called) was originally settled during the 1640s by Dutch farmers.

According to various historical sources, the name "Cobble Hill" came from the large amount of cobble stones being disposed in the site. The cobble stones were used as ballast on the trading ships arriving from Europe. The high elevation point at the corner of present-day Atlantic Avenue and Court Street, where the greatest amount of the cobble stones was disposed, was used as a fort during both the American War of Independence (1775–1783) and the War of 1812 (1812–1814).

Cobble Hill, Brooklyn
Sony SLT-A55V | ƒ/5.6 | 1/80 second | ISO 200

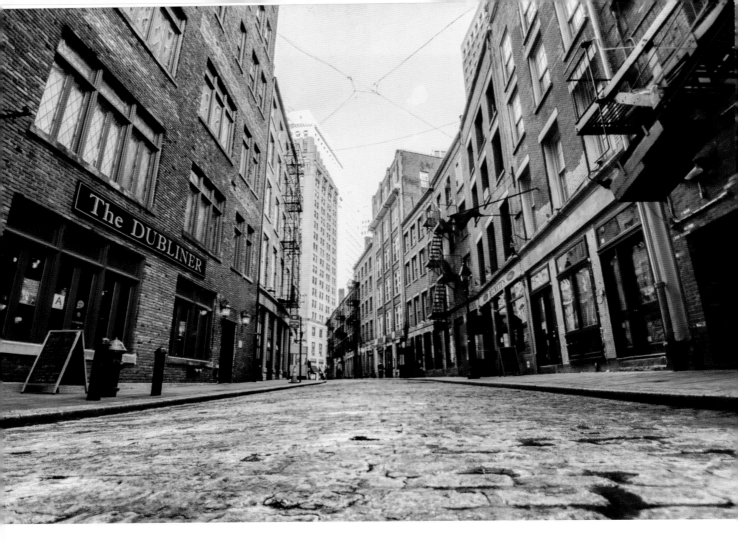

Stone Street is a narrow cobblestone alley that was first developed by Dutch colonists in the 1600s. Its claim to fame is that it was the first street in New York City to be paved, around 1658, and as such it is recognized as a historic landmark. The street is the site where British merchants traded and sold goods, where American colonialists passionately spoke of independence, and where tracts of land were purchased and sold (completely disregarding the earlier inhabitants of the area).

The name Stone Street didn't come about until the late 1700s; before this the alley was called Hoogh Straet, then Brouwer Street, and it also spent some time as Duke Street. Since the street is so close to the waterfront, it was the site of a tremendous amount of commercial activity for two centuries.

In the mid-1800s the area was destroyed by the Great Fire. Even though the Great Fire leveled hundreds of buildings in the area, the Stone Street district bounced back due to New York City having the leading maritime port in the country. However, in the mid-20th century the area saw a decline due to maritime activity moving to the west side of Manhattan. In the mid-1990s, funding was secured to restore the area back to its former glory.

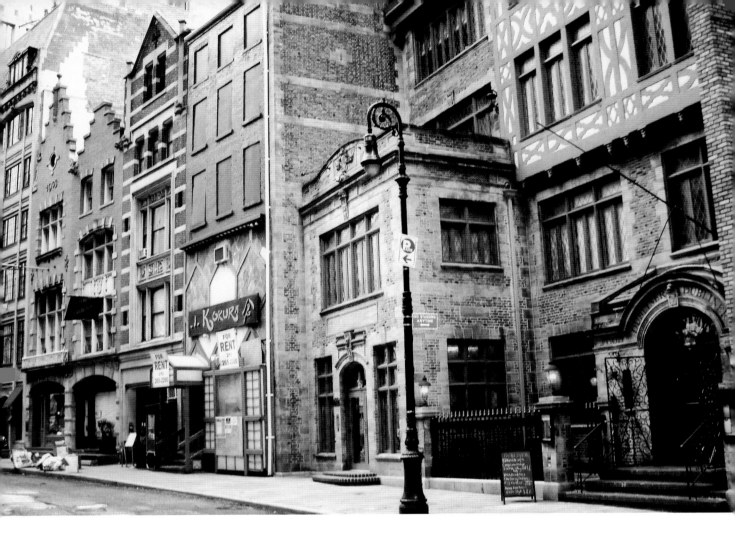

Something I absolutely love about New York City is that tucked away between the towering monuments of modernity are streets that look as if they have been transported from another era and geographic location entirely, suspended in time like flies in amber.

In 1903, the architect C. P. H. Gilbert designed new facades on the buildings in this section of South William Street (57 Stone Street on the other side). Gilbert's Dutch Renaissance-inspired architecture features structural details like stepped gables and strap work and was a nod to the early settlement of Manhattan by Dutch colonists.

The surrounding section of Stone Street was rebuilt with granite bases of post-and-lintel construction and upper-additions of brick, which were specifically erected for importers and merchants.

▲ The Financial District, Lower Manhattan
Samsung E15 | ƒ/4 | 1/60 second | ISO 200

▼ The Financial District, Lower Manhattan
Sony SLT-A99V | ƒ/3.2 | 1/80 second | ISO 400

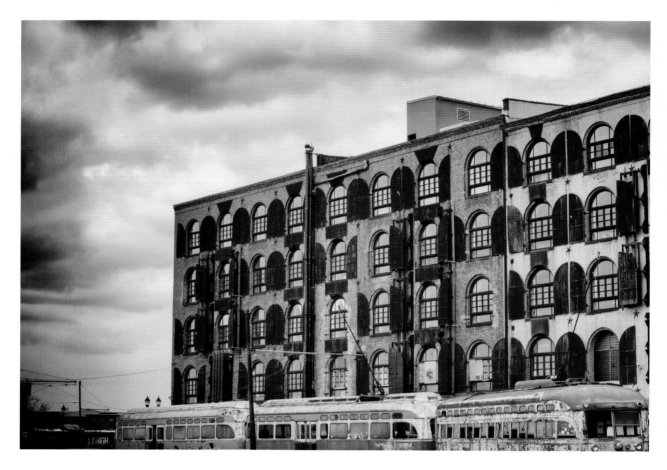

Red Hook, located in Northwestern Brooklyn, was settled in 1636 by Dutch Colonists who named the area Roode Hoek (red point) after the red hue of the soil and because the area jutted out into the water. At the end of the Civil War, New York City was receiving such a large amount of goods that Manhattan could not handle all the cargo. Brooklyn's waterfront became the alternative, and warehouses like this one played a crucial role in offloading cargo like grain, cotton, hemp, jute, indigo, leather, fruits, tobacco, vegetables, cocoa beans, and coffee. This building now houses a Fairway Market and apartment residences. The beautiful iron shutters were originally intended to protect the precious cargo stored in the warehouse from the elements.

The decayed trolley cars that sit in the foreground also have an interesting link to the past. Up until the 1950s there were many trolley lines that criss-crossed the Brooklyn landscape and served as transportation for residents. To celebrate the trolleys that would have been seen here for many years, these trolleys were acquired and put in front of the Red Hook Stores permanently. They aren't from New York City originally though: these trolley cars were acquired from Boston and Oslo and were repainted to match the original color scheme of the trolleys that would have been found in Brooklyn at the beginning of the twentieth century. Worn by time and natural elements, they are beautiful examples of urban decay.

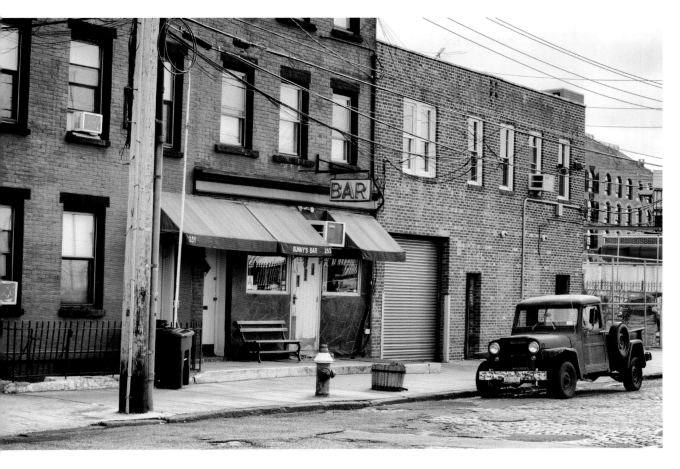

Sunny's is a 120-year-old saloon located in Red Hook, Brooklyn. The bar is named after Antonio "Sunny" Balzano, who was born in 1934 in the deep red brick apartment right next to the bar.

The bar was originally run by Sunny's uncle, John Balzano, when business revolved around the shipping industry. Having relocated to India in the 1970s, Sunny returned to Red Hook in the 1980s and worked for his uncle in the bar. By this time the neighborhood was a shell of what it used to be. The shipping industry had moved its operations across the harbor to New Jersey, and for many years the streets remained quiet and forlorn. John operated the bar just to keep busy, with only a little business from a few neighborhood regulars.

When Sunny took over the bar in 1994, however, the neighborhood was already beginning to change. Red Hook has since been embraced by developers, the arts community, and families looking to settle in a quiet part of Brooklyn. And Sunny's still exists: a testament to Red Hook's colorful history.

🔺 Red Hook, Brooklyn
Sony SLT-A55V | *f*/11 | 1/60 second | ISO 100

🔻 Red Hook, Brooklyn
Sony SLT-A55V | *f*/14 | 1/200 second | ISO 100

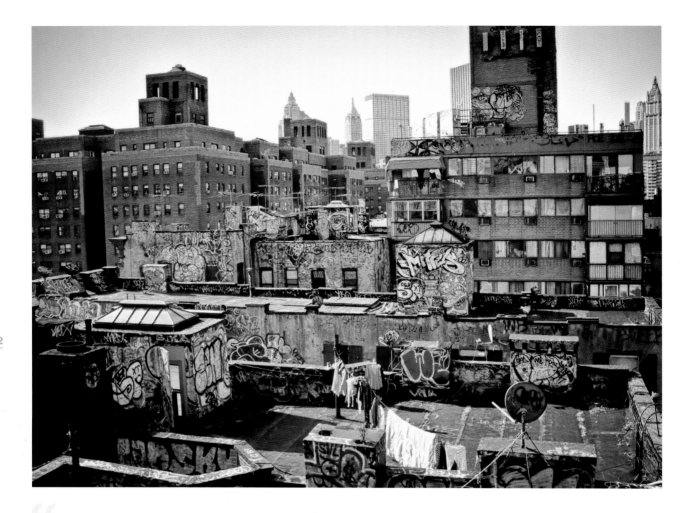

"

Looking out over the rooftops of Chinatown, it's hard not to notice the layers of graffiti that cover the tops of the tenements. Rooftop doors are often ajar and clothes carefully hung on clotheslines to dry sway in the wind.

"

Two Bridges, the Lower East Side, Manhattan
Samsung E15 | ƒ/4 | 1/60 second | ISO 400

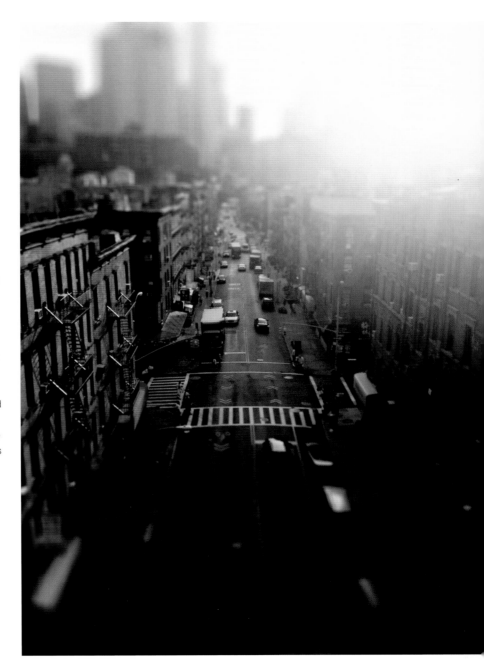

These tenements are part of an area called Two Bridges, which sits between the Brooklyn Bridge and Manhattan Bridge at the southern end of the Lower East Side in an area that is also disputed to be Chinatown.

Situated along the East River, Two Bridges has long been a dwelling spot for many different immigrant communities over the years. It sits alongside the infamous and historic Five Points area, where Irish, Jewish, and Italian gangs battled to the death in the mid-nineteenth century. Currently home to a large community of Chinese immigrants, many of the buildings are tenements dating back to the late-nineteenth and early twentieth centuries.

Two Bridges, the Lower East Side, Manhattan
iPhone 4S

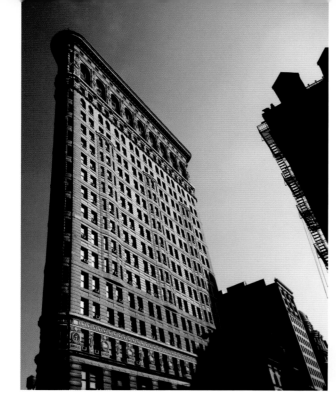

🔺 Flatiron District, Upper Manhattan
iPhone 4S

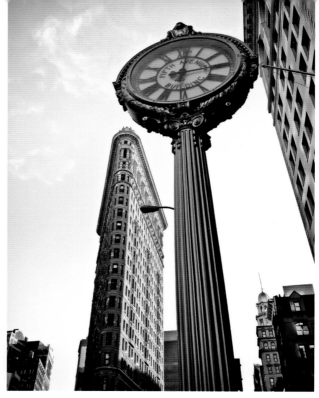

🔺 Flatiron District, Upper Manhattan
iPhone 4S

I have always loved the ornate clocks that line 5th Avenue, especially the Fifth Avenue Building Block that has a prime destination near the Flatiron Building. 19 feet high, the cast-iron clock was installed in 1909 and was crafted by a Brooklyn Iron Works company. It's a type of clock that was introduced in the 1860s. They were popular with business owners who wanted to attract extra attention and also served a functional purpose as time-telling pieces in a busy area of Manhattan.

The juxtaposition between the Flatiron Building, one of New York City's iconic skyscrapers, and this cast-iron clock has always put a smile on my face. The Flatiron Building, which was completed in 1902 is also a landmark in Manhattan. Its name is in reference to its resemblance to a cast-iron clothes iron.

There are a few castle-like structures in New York City. You can see one of them on the page opposite. The Cloisters can be found in Fort Tryon Park in Upper Manhattan. The main buildings are assembled from architectural remnants dating from the twelfth to the fifteenth centuries.

▶ Fort Tryon Park, Manhattan
Sony SLT-A55V | ƒ/5 | 1/40 second | ISO 500

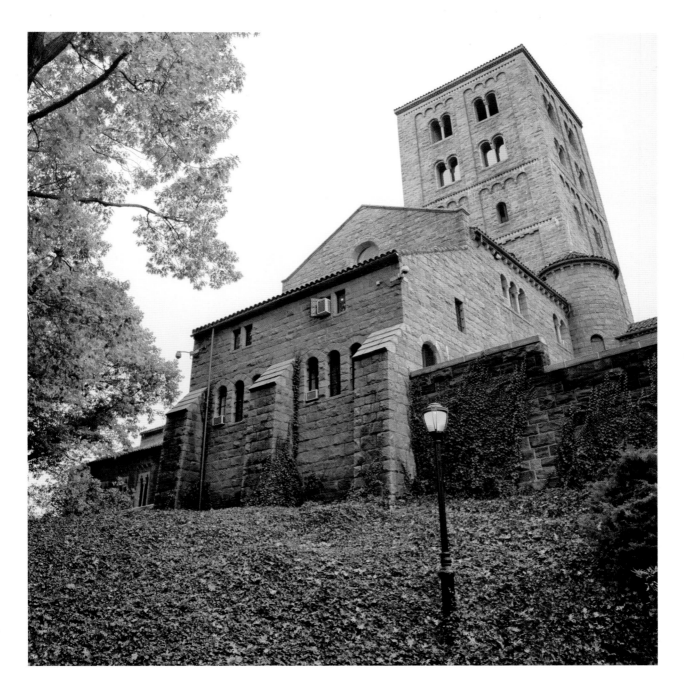

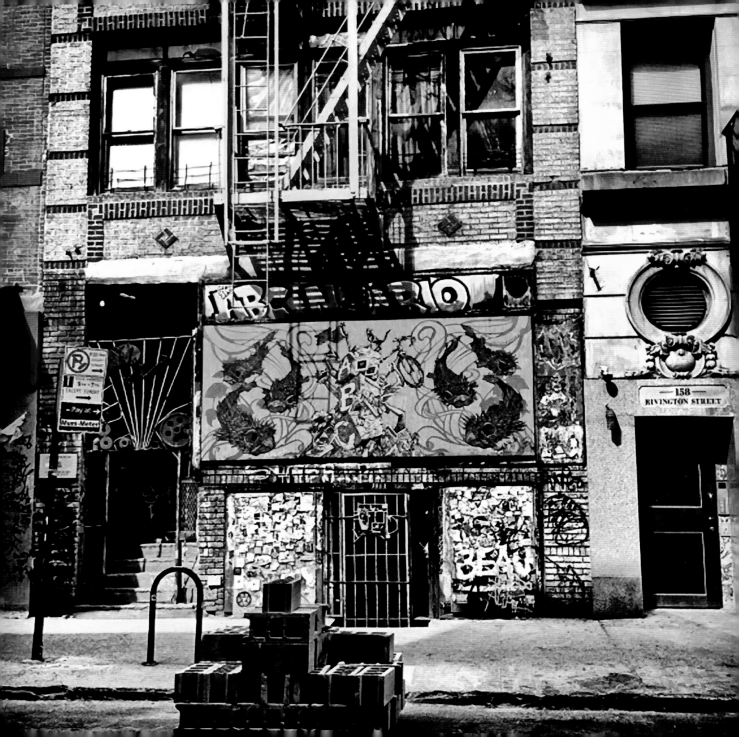

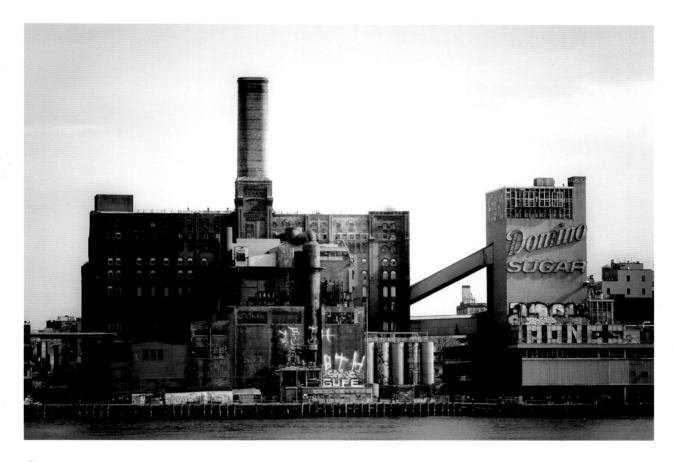

▲ Williamsburg, Brooklyn
Sony SLT-A55V | ƒ/7 | 1/80 second | ISO 200

◀ The Lower East Side, Manhattan
iPhone 4S

ABC No Rio, left, is a collectively run center for art and activism located on Rivington Street on the Lower East Side in Lower Manhattan. It was founded in 1980 by artists committed to political and social engagement with the goal to facilitate cross-pollination between artists and activists.

There is something touching about urban decay. Sorrow and longing can be traced in the peeling layers and crumbling brick. In warm sunlight, iron oxidation produces beautiful textures on old pipes and metal framework. The memory of those who worked insides these structures is preserved by the remnants that remain.

Following the Civil War, New York was the top provider of refined sugar to the United States. For a period of time, the Domino Sugar factory in Williamsburg, Brooklyn (above) was the largest sugar refinery in the world. The factory employed over 4,000 workers and processed three million pounds of sugar a day.

After nearly 150 years of service, the factory shut down in 2004 due to a decline in demand. While the future of the Williamsburg waterfront remains to be seen, the factory lives on in photography.

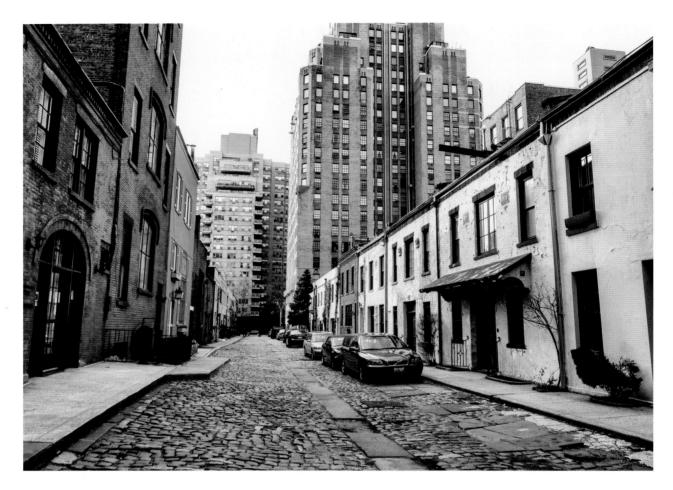

This is an area known as Washington Mews. In the eighteenth century, this area was part of a large farm that contained private stables used by men such as nineteenth-century architect, Richard Morris Hunt, John Taylor Johnston, who was the founding president of the Metropolitan Museum of Art, and Pierre Lorillard, who was a prominent American tobacco manufacturer.

In the first half of the twentieth century, a community of about 200 painters and sculptors flourished on this particular street and another adjoining street in the area. In 1903, a reporter for the *New York Tribune* wrote: "One finds a strange mixture of bales of hay and enormous blocks of marble, boxes of plaster and barrels of oats littering the roadways. Truckmen in greasy jumpers touch elbows now and then with the sculptors in their clay-spattered working garb."

One of the more prominent artists who had a studio on this beautiful street was Edward Hopper. Hopper lived close to Washington Mews at 3 Washington Square from December 1913 until his death in 1967.

▲ Washington Mews, Greenwich Village
Sony SLT-A55V | *f*/4 | 1/125 second | ISO 200

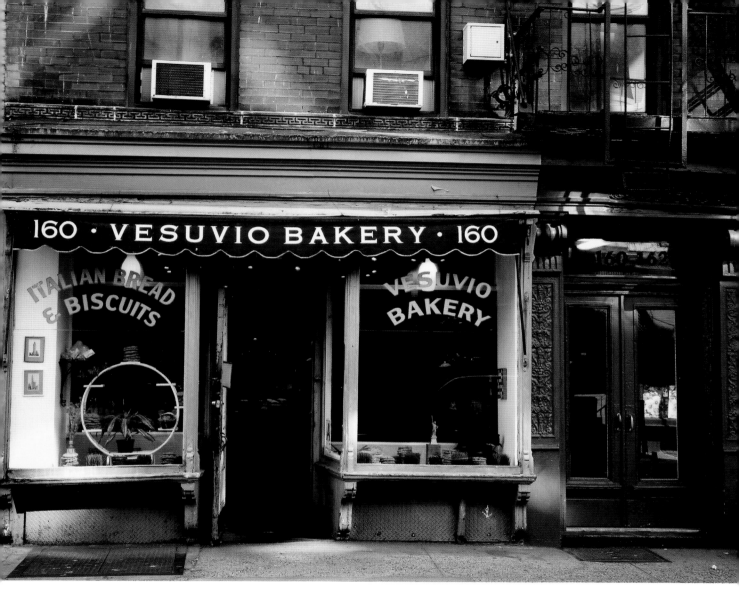

A little over 90 years old, Vesuvio Bakery at 160 Prince Street still looks as it did for decades. It was opened in the 1920s by Nunzio and Jennie Dapolito, and remained in the Dapolito family until 2003. Since then, Vesuvio has changed hands many times, but it is currently still operating as a bakery and, though the name has also changed, the owners have kept the storefront intact.

Prince Street, Soho
Sony SLT-A55V | f/5.6 | 1/80 second | ISO 400

CONCLUSION

"

The act of photographing a city like New York City is similar to the thrill of capturing a firefly in a jar briefly.

New York City is one of the most elusive creatures that one can dare to capture.

It's a city that rarely remains still.

And yet it leaves such an indelible series of impressions.

There is a bittersweet quality that comes with pursuing photography in New York City.

All the moments and backdrops that weave their way into photographs are subject to the same ephemeral transience that New York City exudes.

I look back at the feelings and moments I have attempted to capture over the years and all of it seems like a dream…

…a wonderful dream.

"

Above Times Square, Midtown Manhattan
Sony A7R ┊ f/8 ┊ 2.5 seconds ┊ ISO 50

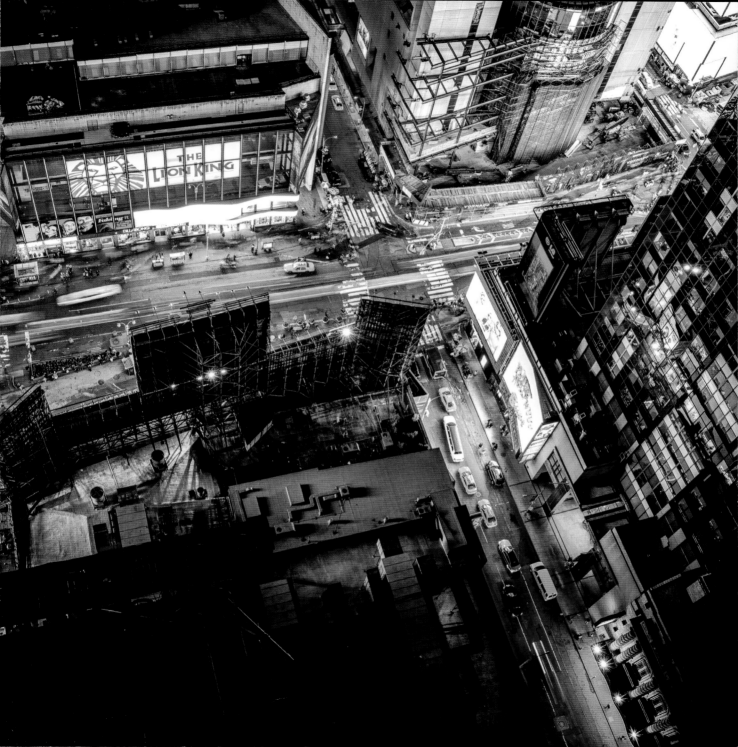

12-30-14
30 —

ACKNOWLEDGMENTS

Dedicated to:
Those who dream with their eyes wide open.

Thanks to:
Sony for making my dreams take shape.

Ilex Press for taking great care of my dreams
and putting them onto paper.

And a very special thanks to:
Spencer: My undying gratitude for igniting the
fire within and the endless kindling of the flames.
Without you, the dream would never have started.

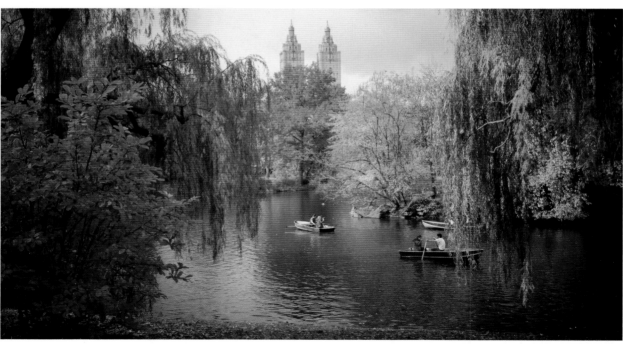